Three Decades *of* Contemporary Art

The Dr. John & Rose M. Shuey Collection

CRANBROOK ART MUSEUM

Introduction
GREGORY WITTKOPP

Preface
GERHARDT KNODEL

with Essays on the Collection by
DORA APEL
RICHARD H. AXSOM
JEFFREY D. GROVE
IRENE HOFMANN
DIANE KIRKPATRICK
DENNIS ALAN NAWROCKI
LISA PASQUARIELLO
SARAH SCHLEUNING
LISA WAINWRIGHT
GREGORY WITTKOPP

THREE DECADES OF CONTEMPORARY ART *The Dr. John & Rose M. Shuey Collection*

Three Decades of Contemporary Art: The Dr. John and Rose M. Shuey Collection documents Rose M. Shuey's gift of forty-six paintings and sculptures to Cranbrook Art Museum. The collection was presented in an exhibition at Cranbrook Art Museum December 8, 2001, through April 7, 2002.

Project Director and Curator: GREGORY WITTKOPP
Editor: DORA APEL
Catalogue Coordinators: GREGORY WITTKOPP and IRENE HOFMANN
Researchers: SARAH SCHLEUNING and ROBERTA FREY GILBOE
Collection Preparator: JESS KREGLOW
Designer: KATHRYN AMBROSE
Color Photography: R.H. HENSLEIGH
Printed in Germany by CANTZ

Front cover image: © Robert Rauschenberg/Licensed by VAGA, New York, NY
Back cover image: © Tom Wesselmann/Licensed by VAGA, New York, NY

©2001 Cranbrook Art Museum

39221 Woodward Avenue
P.O. Box 801
Bloomfield Hills, Michigan 48303-0801
248-645-3323
www.cranbrook.edu

ISBN 0-9668577-3-9

Cranbrook Art Museum is a non-profit contemporary art museum and is an integral part of Cranbrook Academy of Art, a community of artists-in-residence and graduate students in art, architecture and design. Cranbrook Academy of Art and Art Museum are a part of Cranbrook Educational Community, which also includes Cranbrook's Institute of Science, Schools and other affiliated cultural and educational programs.

Cranbrook Art Museum is supported in part by its members, the Michigan Council for Arts and Cultural Affairs and the fund-raising activities of the Serious Moonlight Steering Committee, the Museum Committee and the Women's Committee of Cranbrook Academy of Art and Art Museum.

The Cranbrook signature is a registered trademark of Cranbrook Educational Community.

TABLE OF CONTENTS

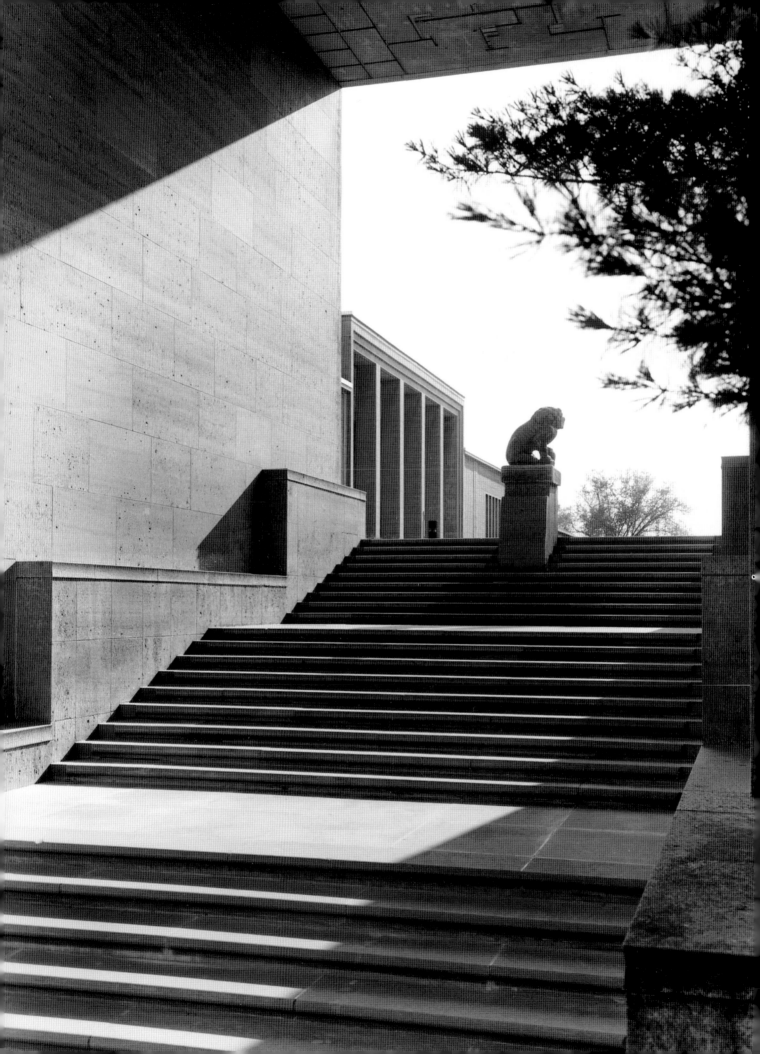

PREFACE

All artists savor the notion that their works, brought into the world with extraordinary attention and deep affection, may find places to reside meaningfully in the life experiences of others. The recent gift to Cranbrook Art Museum of the Dr. John and Rose M. Shuey Collection of forty-six artworks, by many of America's and Europe's most important artists of the post–World War II era, establishes a new potential in the life of these artworks as they come to live in our educational community, which is focused on inspiration and discovery. We are deeply appreciative of this new-found relationship and the potential that emanates from it.

From the moment of Art Museum Director Gregory Wittkopp's report on his first meeting with Rose Shuey to the time of the arrival and unpacking of the collection, our heads have been spinning with exciting prospects inspired by the gift. We greatly appreciate Greg's unfailing vision, optimism and dedication to realizing this project for the Art Museum which has brought our shared aspirations closer to realization.

The gift comes to Cranbrook at a most auspicious time and presents exciting opportunities for our institution. For many years, the collecting focus of the Museum has been related to works produced by outstanding artists, designers and architects whose personal careers have intersected with the Academy throughout its seventy-year history. Now, in one dramatic moment, we have broadened the scope of our collection to once again align ourselves with George Booth's original intentions, not only to see the best of art of our own time regardless of its source, but, when possible, to collect it. Cranbrook welcomes this new chapter and the potential it heralds for the larger art community. This beneficence comes at a time when all the art institutions in Southeast Michigan have deepened their relationship to one another and this gift strengthens not only Cranbrook, but also our regional and national cultural identity.

The Shuey collection will allow us to bridge radical new experiences with artistic antecedents through the work of these important contemporary artists, reminding us that new art stands on the shoulders of that which has come before. The Shuey gift also enhances the role of the Museum as an effective resource for our Academy resident artists, graduate students and staff, as well as the general public. Our ability to have a primary experience with these works of art will contribute to our understanding of artistic development.

The Shuey gift exemplifies the pleasure and passion of collecting art that accompanies the owners' individual lives in unusual ways. To the collector, artworks exist in relation to one another throughout the collector's lifetime. The Shuey gift reminds us that although an individual collector's relationship with objects is temporary, the collector can find great pleasure in gifting the collection to a museum where relationships and accessibility are secured in perpetuity. One's living room can never accommodate the number of visitors to a museum!

While we savor our legacy at Cranbrook and its continuity in time, we are not complacent regarding its future. Our current major capital improvements and new construction are in response to the needs of the Museum and Academy. A master plan by Rafael Moneo, architect of our New Studios Building, anticipates an expanded Museum for exhibitions, collections and public events. There is much to be done, and the Shuey gift exemplifies the great generosity of individuals who see to it that our dreams may be realized.

I join my colleagues in expressing our deepest gratitude to Rose Shuey.

—GERHARDT KNODEL
 Director, Cranbrook Academy of Art
 Vice President, Cranbrook Educational Community

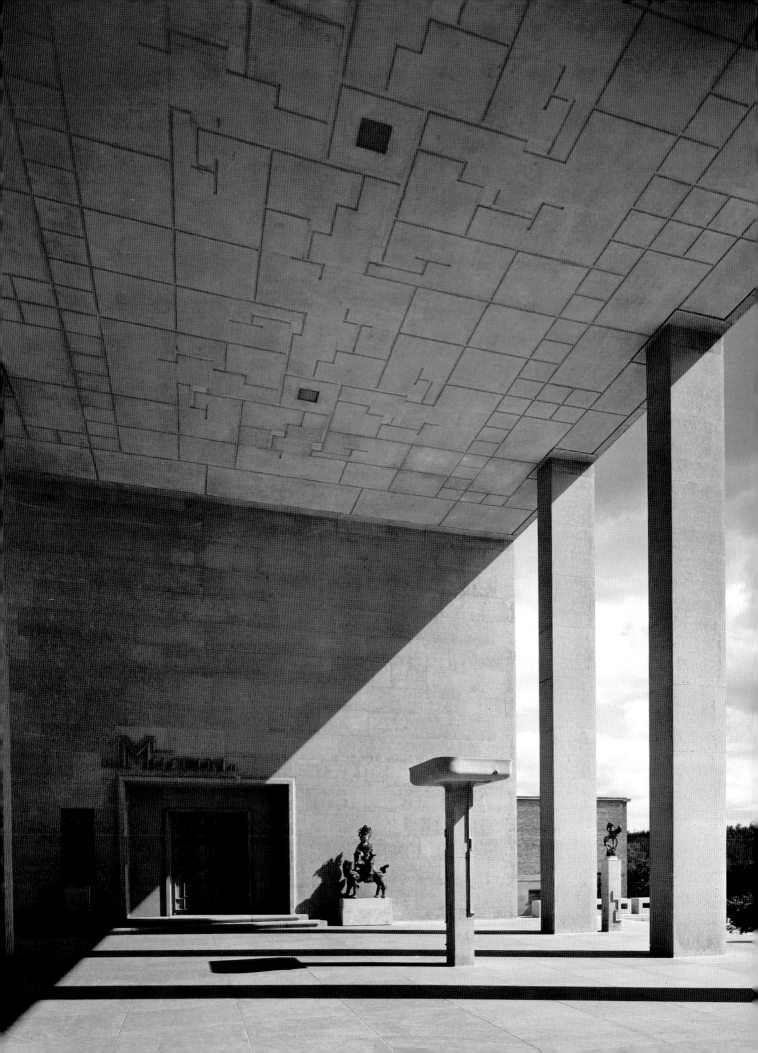

ACKNOWLEDGEMENTS

It is not often that a museum has a chance to reinvent itself. Rose Shuey, through her gift of the Dr. John and Rose M. Shuey Collection, has provided us with an opportunity to rewrite our mission and chart a bold new direction for the future. With the Shuey Collection, we now have a core collection of outstanding twentieth-century art that will not only help us to contextualize our temporary exhibitions, but also allow us to return to the mission of our founder, George Gough Booth, who worked to develop an art museum with a broadly defined collection of contemporary art. Booth envisioned a collection that could present the work of Cranbrook artists in the context of outstanding national and international artists. We thank Rose Shuey for this opportunity to reaffirm our role as a leading museum of modern and contemporary art.

Many people have contributed their support and resources to this project, including the exhibition and catalogue. First and foremost I thank Dr. Stanley Grandon who introduced me to Rose Shuey and encouraged her to consider donating her collection to Cranbrook. Without his support, the collection—like so many others—might have left the area.

The acquisition of such an important collection by a museum should be a process that engages every level of leadership. I join Cranbrook President Rick Nahm and Academy Director Gerhardt Knodel in offering my gratitude to Cranbrook's Trustees and Governors. Under the leadership of Robert Larson, Chair of the Board of Trustees; Richard Janes, Chair of the Academy of Art Board of Governors; and Erica Ward Gerson, Chair of the Collections Committee, this gift and the opportunities it creates were thoughtfully reviewed and embraced by the people that have made a substantial commitment to Cranbrook's continued excellence as an educational institution.

Among the most zealous champions of this project were Maxine Frankel and David Klein, Co-chairs of the Art Museum's Museum Committee. Every step of the way, from the initial conversations with Rose Shuey to the publication of the catalogue, they graciously offered their expertise and support. The Art Museum and its director could not ask for two better friends. They, in turn, lead a dedicated committee comprised of both Governors and community representatives that share our vision for the future of this museum. I thank those members in particular who helped fund this catalogue: Burt Aaron, William Aikens, Maggie Allesee, Jonathan Boos, Frank Edwards, Stephen Fox, Stanley Grandon, Jonathan Holtzman, Richard Janes, Diane Kirkpatrick, Beverly Moore, Susan Takai Nathan, Marc Schwartz and Jon Weaver.

My enthusiastic partners at the Art Museum include Roberta Frey Gilboe, our Registrar, and Jess Kreglow, our Preparator, who orchestrated the movement of the artworks from Rose Shuey's home to the Art Museum, and supervised the uncrating, conservation, photography and installation of the collection. I also relied on Roberta for many other details, from securing copyright permissions to assisting with copy editing the catalogue. She is a true professional. The team also includes Assistant Curator Sarah Schleuning, who did the initial research on the collection; our former Curator of Exhibitions, Irene Hofmann, who coordinated the initial work on the catalogue; and Denise Collier, Vanessa Glasby, Melissa Goldman and Carol Cleaver who supported this project in numerous ways.

I also thank the art historians who worked on this project. Their essays thoughtfully contextualize the works within the history of twentieth-century art and provide us with illuminating insights into their meaning and value as cultural artifacts. On behalf of the writers, myself included, I also would like to thank the catalogue's editor, Dora Apel, who not only helped us to focus and clarify our initial drafts, but also edited the final texts with surgical precision. In addition, we are indebted to Kathryn Ambrose for her elegant and clear design, and Shell Hensleigh for his precise new color photography. I also thank Mark Coir, Director of Cranbrook Archives, and Laura Mancini, Archivist, for providing the vintage images of Cranbrook.

Finally, I would like to thank Rose Shuey for her vision of the profound impact these works can have on the many audiences who visit Cranbrook. She has used this gift to chart a bold new chapter in her own life, just as she has helped create one for Cranbrook Art Museum. Her warmth and energy, enthusiasm and generosity have touched us all.

 —GREGORY WITTKOPP
 Director, Cranbrook Art Museum

INTRODUCTION
The Dr. John & Rose M. Shuey Collection
BY GREGORY WITTKOPP

In the fall of 1969 the American painter Frank Stella was about to premier a series of monumental paintings at the Leo Castelli Gallery in New York City. Celebrated in the 1960s for his Minimalist geometric abstraction, Stella had been working on a series of paintings based on the circular movement of a protractor. To announce the opening of the exhibition on November 18, Castelli mailed to his clients a small folded poster with a full-color reproduction of one of Stella's newest paintings, *Takht-i-Sulayman Variation I*. Bearing the name of an ancient circular city in Asia Minor, *Takht-i-Sulayman* is a monumental work depicting the razor-sharp interlocking of circular and semi-circular forms within the framework of two ten-foot squares that plunge the observer into what Robert Rosenblum described as a "dizzying tour de force of aesthetic engineering." By all accounts, the exhibition was a success, but *Takht-i-Sulayman Variation I* remained unsold. After all, it was an exceptional collector who had room to hang a ten-by-twenty-foot painting in their living room.

Two of the collectors on Castelli's mailing list were Dr. John and Rose M. Shuey in Detroit. Although they already had purchased several significant works for their growing collection, including a sculpture by Louise Nevelson, and were about to buy a large painting by Roy Lichtenstein from Castelli, they did not have a painting by Stella. They remained in communication with Castelli and Barbara Wool at the gallery and in the fall of 1970 they were encouraged to consider two important works by the artist, including *Takht-i-Sulayman Variation I*. Certainly not intimidated by the size of the work (the Larry Poons that they would buy in 1978 measures almost ten by sixteen feet), they flew to New York to view the painting in Castelli's warehouse, fell in love with it, purchased the work a few months later, and had it shipped to their modest home in Detroit—*where it sat in a hallway sealed in its crate for the next thirty years.*

John and Rose Shuey both were raised in Detroit. Born Rose Ostapenko in Winnipeg, Manitoba, Canada, Rose moved with her parents at an early age to Detroit where her father worked in the design department at the Ford Motor Company. John Czuj (although John and Rose both used Shuey as the phoenetic spelling of John's Polish surname, Czuj remains the legal name) was born in Detroit and studied philosophy at the University of Detroit and medicine at Wayne State University where he earned his degree as a doctor certified in internal medicine with a specialty in cardiology. John became Chief of Staff at Mt. Carmel Mercy Hospital in Detroit and St. Mary's Hospital of Livonia and had a small private practice in Detroit located near Livernois Avenue and McNichols Road. Childhood friends, Rose and John married in 1953 and lived in a modest two-family home in Detroit, where Rose's parents continued to occupy the first floor flat.

Although Rose fondly remembers her childhood visits to the Detroit Institute of Arts, neither of them had a background in art. Immediately after they married, however, they began making trips to New York City every year where they took in the cultural attractions, including the Metropolitan Opera in the evening and the museums and galleries during the day. Like many young collectors, they found themselves attracted to early modern art including Impressionism and—in Rose's case in particular—Surrealism. But in the 1950s the international contemporary art scene shifted to New York. As Rose recalls, "From the beginning you simply could not ignore contemporary art. Every gallery was showing it. That was the thing to fall in love with, and that is what we did."

By the 1960s the Shueys began to aggressively collect contemporary art. They made numerous trips to New York each year to attend the auctions in November and May and regularly attended the openings at the private galleries, often flying in just for the afternoon because of John's demanding schedule at the hospitals. They educated themselves by befriending the gallery owners, meeting with the artists and reading the art journals and reviews in *The New York Times*. One by one they formed a collection of paintings and sculptures that deliberately reflected the diversity of contemporary art, the art of their time. Rose was left as the steward of the collection when John died in 1999. In the summer of 2001, I interviewed her.

GREGORY WITTKOPP: Did you and John agree on all the works you purchased?

ROSE SHUEY: *No, not necessarily. Sometimes we had little contentions as to which piece we should buy, and we didn't buy any. Other times, and I am talking about the two works by Frank Stella from the Imaginary Places series in particular, he bought his and I bought mine. Now that's true collecting.*

GW: Is there a single painting or sculpture that represents the type of work that John was interested in collecting?

RS: *Yes, I would say that it would be the Rauschenberg. That was one of the biggest and certainly one of the most expensive works that we bought. And it's a glorious piece. With the electrical bulbs hanging down to provide light so that you can see the collaged images reflected on the mirrored surface of the angled panel, you can't walk past it without spending time looking at it.*

GW: What did you think of the Rauschenberg when you first saw it?

RS: *I liked it, but I preferred his paintings that incorporated screen doors. They just were unattainable for the normal collector. And don't forget, we were outsiders. We didn't live in New York and couldn't fly in all the time. The galleries had a list of much more established clients that had a lot more money than what we had and naturally, those people usually got the first choice of everything.*

GW: Perhaps, but the screen door paintings now seem more commonplace—as you mentioned, every museum has one—while your *Moon Burn* seems fresh and original.

GW: Tell me about your own sensibilities as a collector.

RS: *While John was attracted to the more monumental works, I don't see anything wrong in turning a corner and coming face to face with a little gem. Everything didn't have to be the biggest of the show. Everything didn't have to be the most expensive. I need to have a more intimate relationship with the work.*

GW: What is one of your favorite works in the collection?

RS: *I love the Agnes Martin.*

Like *Takht-i-Sulayman Variation I* by Frank Stella, Robert Rauschenburg's *Moon Burn* and Agnes Martin's *Untitled* painting were shipped to the Shuey's home in Detroit where they remained in their crates packed tightly together in the first-floor flat of Rose's mother, Mrs. Ostapenko. With the exception of the few paintings that they agreed to loan to museum exhibitions, including the painting by Joan Mitchell and the more colorful of their two works on paper by Richard Diebenkorn, the only work that Rose and John had on view in their home was the *Floating Figure* by Willem de Kooning. But this was not their intention when they began their collection.

In the late 1960s they commissioned the architect Paul Rudolph (1918-1997) to design a home for them on land they had purchased in Bloomfield Hills, less than a mile from Cranbrook, at the corner of Long Lake Road and Epping Lane. One of the central figures of postwar American architecture, Rudolph was famous in the 1950s and 1960s for his sculpturally molded concrete structures with highly textured surfaces that fractured the reductivist modernism of the International Style as espoused by Mies van der Rohe and Rudolph's teacher at Harvard, Walter Gropius. Referencing instead the late works of the French architect Le Corbusier, in particular his pilgrimage chapel Notre Dame du Haut at Ronchamp, France (1950), and certainly sympathetic to the sculptural goals of architect Eero Saarinen, Rudolph's work

is part of Modernism's more expressive "baroque" phase often referred to as Brutalism. Two of his most famous buildings are the Endo Laboratories Complex in Garden City, New York (1962-1964), and the Art and Architecture Building at Yale University in New Haven, Connecticut (1959-1963), where he was chairman of its influential architecture department from 1958 to 1965.

Like the artists that the Shueys were collecting, Rudolph was at the height of his career when he designed their home. Arthur Drexler, Director of the Department of Architecture and Design at the Museum of Modern Art, featured his work in his "Work in Progress" exhibition (October 1, 1970, to January 3, 1971) that included the work of just two other architects, Philip Johnson and Kevin Roche, and Praeger Publishers had just released a monograph on Rudolph's architecture with an introduction by Sibyl Moholy-Nagy. But the 5,500 square-foot Shuey Residence in Bloomfield Hills, with its dramatic intersecting vaulted spaces and horizontal glass spans opening between sloping floors and overlapping vaults, was unique within the architect's career and would have been one of the most radical houses of the twentieth century, making Rudolph's first completed house in Michigan—the Dr. Frank H. Parcells Residence in Grosse Pointe—seem tame by comparison. For a variety of reasons, including the fact that Rudolph's modernist vision left little room for paintings, the relationship with the architect soured and his design and scale model for the house—like the paintings and sculptures in the Shuey's collection—remained in a crate.

> **RS**: *Mr. Rudolph was a great spatial man, but I don't really think that he liked to have art hanging on the walls. At one point, John proposed the idea of having art on panels that you could slide back and forth. But later on, I thought to myself, the solution was to have a house with smaller living quarters and an attached museum. Then we would not have had to reconcile the architect's spatial relationships with more practical considerations, like my need for a pantry and closets.*
> **GW**: Did you consider working with any other architects?
> **RS**: *Yes, sure we did, for a while. But the others did not have the same imagination. They couldn't get the scope of what we were talking about.*

Although John and Rose were most active as collectors in the 1960s and 1970s, they continued to shape their collection in the 1980s and 1990s. One of the last works they acquired was a painting by Alfred Jensen that they bought at auction in 1997. They had been intent on building a collection that represented most of the major trends and movements in contemporary painting and sculpture, especially during the 1960s and 1970s. With the exception of Catherine Murphy's somber *Nighttime Self-Portrait*, they were less interested in the return to figuration that characterized contemporary painting in the 1980s.

> **GW**: Was there ever a moment when you thought you might sell one of the works in your collection so that you could buy a different work by that same artist?
> **RS**: *No. We had a wonderful relationship with our artworks and each one was from a different time of our life. I couldn't give up something, even if it would have been to get something better, because at the time that I bought the work I was totally committed to it and the reason why I initially responded to it.*
> **GW**: So you never sold any works?
> **RS**: *No, I gave a couple away, but I never sold any.*

Rose fondly recalls the social aspects of the New York art community, including the many artists and dealers and critics they met. She remembers the parties at the galleries and studio visits and chance encounters like stopping the art critic John Canady on the corner of Madison Avenue and 69th Street in 1968 and asking for an autograph, which he graciously offered.

> **GW**: You have mentioned that one of the artists that you met and regretted not being able to buy a work from was Francis Bacon. Tell me about meeting him.
> **RS**: *He was breathtaking. We left the Metropolitan Opera early one evening to go to the Marlborough Gallery where he was having a joint opening with Henry Moore. Mr. Bacon spent so much time with me and made me feel so welcome. He was a gentleman and turned out to be a friend.*
> **GW**: On how many different occasions did you meet him?
> **RS**: *Oh, I met him just twice. But it's a sign of affection that he kissed me on both cheeks—unless you're going to tell me that it's just the European way of doing it!*

WILLEM DE KOONING IN HIS STUDIO WORKING ON **Floating Figure**. The photograph by Lawrence Fried originally was published in **Illustrated Newsweek**, September 4, 1972. A copy of this photograph was inscribed by the artist to John and Rose Shuey.

To John and Rob
July
de Kooning

GW: Why didn't you buy a painting by him?

RS: *Well, they were terribly expensive, even at that time, and John and I had a tight budget that we had to work with. But, in retrospect, that was the wrong approach to have taken. When you are collecting art, I think a person should teach themselves to stretch a little, knowing that if you give up some of the other things in life, you will be rewarded in the long run.*

GW: Are there any other artists that you would have liked to have included in your collection?

RS: *Mark Rothko and Alexander Calder.*

When John died in November of 1999, Rose began to consider her options regarding the collection the following year. The introduction to Cranbrook came through Dr. Stanley Grandon, an associate of John's in the Detroit medical community. Stanley and Barbara Grandon, who have their own significant collection of contemporary art with a focus on figurative painting, often met John and Rose in New York during the Fall and Spring auctions of contemporary art. After joining the Museum Committee at Cranbrook Art Museum, Grandon suggested to Rose that she begin a dialogue with me to see if we would be interested in this outstanding body of work for the Museum's permanent collection. This began our rich and fruitful relationship.

GW: What led to your decision to ultimately donate the collection to Cranbrook Art Museum?

RS: *It never was my intention to put the collection up for sale. Most of the art we collected is museum caliber. We always felt we had some fantastic works and that they deserved to be seen and enjoyed in a museum by the public where they can have an ongoing dialogue with these paintings and sculptures. I also feel that Cranbrook Art Museum's mission within an educational community is the perfect location for the works. I hope that the older visitors will enjoy our collection and that the Academy students will learn from them. Cranbrook is the perfect home for them.*

In anticipation of this generous gift, Rose loaned the works to Cranbrook Art Museum in the winter of 2001 and shared our excitement as we began to open the crates. Although she had not seen most of the works for several decades, she nonetheless derived immense pleasure from owning them and having them in her home, demonstrating a vivid recollection of every single painting and sculpture in the weeks and months before they actually were unpacked. When we met for the first time at her home in Detroit she described in precise and colorful detail the crated paintings by Robert Motherwell, Bridget Riley and Robert Rauschenberg, the sculptures by Donald Judd, Louise Nevelson and Anthony Caro, and, of course, *Takht-i-Sulayman Variation I* by Frank Stella. Her love for these works makes her gift to Cranbrook all the more remarkable. We share her feeling that Cranbrook Art Museum is the perfect home for the Dr. John and Rose M. Shuey Collection and are honored to have the opportunity to share these outstanding works of art with our students and visitors from around the world.

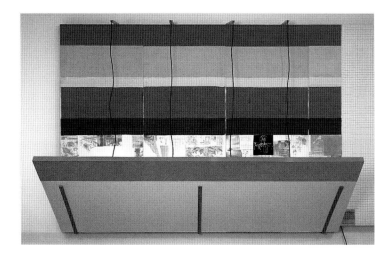 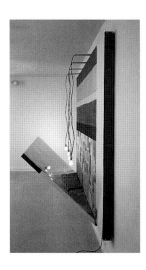

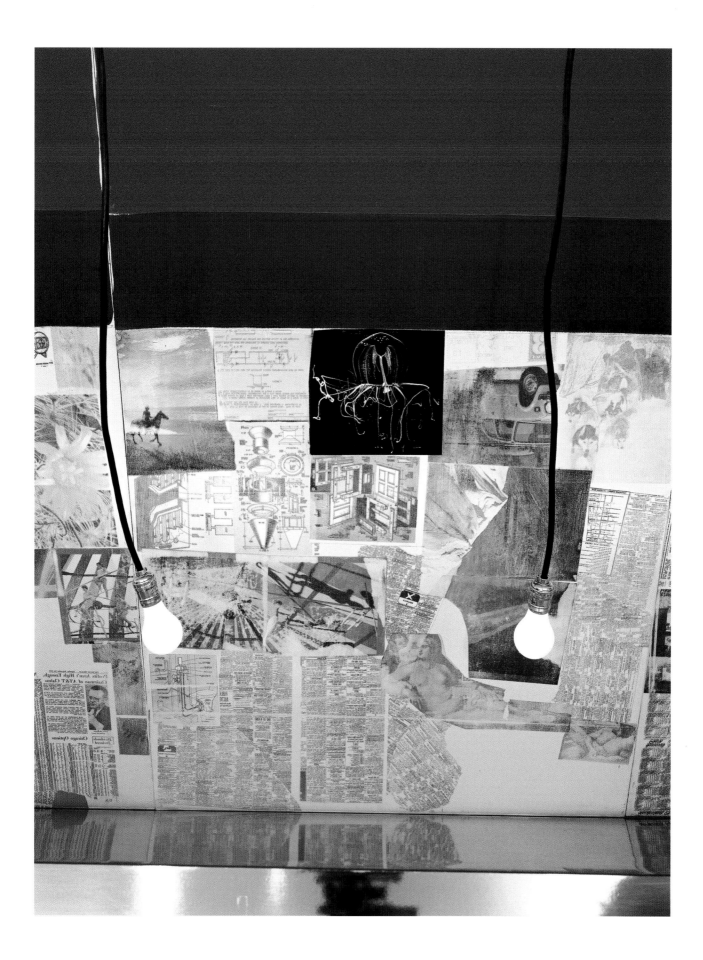

SHUEY RESIDENCE PROJECT, Bloomfield Hills, Michigan, Paul Rudolph, Architect; Perspective of Plan F, Blueprint, June 29, 1971. Models and drawings of the project were published in the Italian architectural journal **Domus** in July 1974 ("Non Construito/Rudolph Unbuilt: una 'villa' nel Michigan," vol. 536, p. 17).

ESSAY CONTRIBUTORS

DORA APEL

Dora Apel is the W. Hawkins Ferry Chair in Modern and Contemporary Art History at Wayne State University. She holds a Ph.D. in Art History from the University of Pittsburgh, and has served as editor for several Cranbrook Art Museum exhibition catalogs, including this catalog, *Iñigo Manglano-Ovalle* (2001), and *Weird Science* (1999). She has written both scholarly articles and reviews of contemporary exhibitions. Her book *Memory Effects: The Holocaust and The Art of Secondary Witnessing* is forthcoming from Rutgers University Press.

RICHARD H. AXSOM

Richard Axsom is Curator of Prints, Drawings, and Photography at the Grand Rapids Art Museum. He holds a Ph.D. in the History of Art from the University of Michigan and was Professor of Art History at the University of Michigan-Dearborn (1973-2001). His extensive publications in the area of contemporary prints include catalogues raisonnés for Ellsworth Kelly, Claes Oldenburg, Frank Stella and Terry Winters.

JEFFREY D. GROVE

Jeffrey Grove is Associate Curator of Contemporary Art at The Cleveland Museum of Art. He holds a B.F.A. in Industrial Design from the University of Illinois, Urbana-Champaign, an M.A. in Art History and Archaeology from the University of Missouri, Columbia, and a Ph.D. from Case Western Reserve University, Cleveland. Grove has organized numerous exhibitions and written widely on contemporary art. He is co-author of *Lee Krasner: A Catalogue Raisonné* and *Akron Art Museum, Art Since 1850: An Introduction to the Collection.*

IRENE HOFMANN

Irene Hofmann is Curator of Contemporary Art at the Orange County Museum of Art in Newport Beach, California. She holds a B.A. in Art History from Washington University in St. Louis and an M.A. in Modern Art History, Theory and Criticism from The School of the Art Institute of Chicago. As the former Curator of Exhibitions at Cranbrook Art Museum (1996-2001), she curated such exhibitions as *Iñigo Manglano-Ovalle* (2001), *Agitated Histories: Video Art and the Documentary* (2000), *Fabula: Consumer Media and Contemporary Art* (2000) and *Weird Science* (1999).

DIANE KIRKPATRICK

Diane Kirkpatrick is Professor Emerita at the University of Michigan, Ann Arbor. She holds a B.A. in History from Vassar College, an M.F.A. in Painting and Sculpture from Cranbrook Academy of Art, and an M.A. and Ph.D. in the History of Art from the University of Michigan. A specialist in contemporary art with focus on the effects of new media, she has published extensively on traditional media, cinema, photography, and electronic media, and guest curated exhibitions on contemporary Chicago art and representations of the World's Columbian Exposition of 1893.

DENNIS ALAN NAWROCKI

Dennis Nawrocki teaches at the College for Creative Studies and Wayne State University, Detroit. He holds an M.A. in English and an M.A. in Art History from Wayne State University. He has curated numerous exhibitions, lectured widely, and written extensively on twentieth-century art; his most recent publication is *Art in Detroit Public Places* (Wayne State University Press, 1999).

LISA PASQUARIELLO

Lisa Pasquariello is a doctoral candidate in the Department of Art History at Stanford University, where she is writing a dissertation on the work of Ed Ruscha. She is the Managing Editor of *OCTOBER* magazine.

SARAH SCHLEUNING

Sarah Schleuning is the Assistant Curator at Cranbrook Art Museum. She holds an M.A. in the History of Decorative Arts and Design from Parsons School of Design/Cooper-Hewitt National Design Museum and a B.A. in Cultural Anthropology from Cornell University. She has curated several exhibitions relating to twentieth-century art, decorative arts and design.

LISA WAINWRIGHT

Lisa Wainwright is an Associate Professor in the Department of Art History, Theory and Criticism at the School of the Art Institute of Chicago. She holds an M.A. and a Ph.D. in Modern Art History from the University of Illinois at Urbana-Champaign. She has written many essays on postwar American art, lectures widely, and guest-curates exhibitions. She currently is working on a book on the history of found objects in art.

GREGORY WITTKOPP

Gregory Wittkopp is the Director of Cranbrook Art Museum and serves as the curator of its permanent collection. He holds a B.S. in Architecture from the College of Architecture and Urban Planning at the University of Michigan and an M.A. in Art History from Wayne State University. He has curated numerous exhibitions and written many essays on the architecture and design of Eliel Saarinen, including the book *Saarinen House and Garden: A Total Work of Art* (Harry N. Abrams, Inc., 1995).

ESSAYS AND COLOR PLATES

Dimensions: Height precedes width precedes depth.

Provenance: The most recent owner of the work is listed first followed by all known past owners in descending order.

Citations: Citations have been limited to references to the specific work or edition in the Dr. John and Rose M. Shuey Collection.

Exhibition History: Exhibitions have been limited to presentations of the specific work or edition in the Dr. John and Rose M. Shuey Collection.

JOSEF ALBERS
(Born 1888, Bottrop, Germany; died 1976,
New Haven, Connecticut)
Homage to the Square: "Festive," 1967
Oil on board
48 x 48 inches (121.9 x 121.9 cm)
Signed verso: "Albers 1967"

Acquired by Dr. John and Rose M. Shuey
through Sidney Janis Gallery, New York,
New York, 1968

JOSEF ALBERS

Josef Albers was a world-renowned painter, designer, teacher, and theoretician. As one of the first modernist artists to focus on color theory and composition, he is credited with influencing the movements of hard-edge Op Art and Minimalism in the 1960s and became the first living artist to have a solo exhibition at the Metropolitan Museum of Art in New York in 1971.

Born in Germany, Albers enrolled as a student at the Bauhaus design school in 1920, becoming a teacher there in 1923 in the foundation course as well as the furniture design and glass workshops until the Bauhaus was forced to close in 1933 by the Nazis. Due to Philip Johnson, then a curator at the Museum of Modern Art in New York, Albers was hired to teach at the experimental Black Mountain College in North Carolina where he remained until 1949. The following year, he became head of the Department of Design at Yale University School of Art where he taught until 1960. As a teacher, Albers influenced many younger painters, such as Richard Anuszkiewicz, Kenneth Noland, Robert Rauschenberg, and Neil Welliver. He formalized his philosophy on color and composition with his 1963 book *Interactions of Color*.

Albers's early work in stained glass helped foster his lifelong interest in problems of light and color within geometric formats. While at Yale, Albers began his most famous series of paintings, *Homage to the Square*, employing a strict formula in which the full innermost square is not centered but positioned near the bottom of the canvas; the size of the color bands at the bottom are doubled on each side of the square and tripled on top. This structure causes the colors to advance or recede in response to each other. The colors, however, are also meant to interact with each other when processed by the human eye in ways that continually change their effects on each other. Albers demonstrated with this series that colors are not absolute in value—producing one "visual truth"—but instead are changeable. Albers thus proved the eye's ability to change colors in unpredictable ways, depending on their proximity to each other.

Dedicated to the use of pure color, Albers started his paintings with six layers of white ground, maximizing the luminosity and saturation of the color placed on top. Then the colors would be applied to their appropriate sections directly from the tube with a palette knife, starting with the center and radiating out (so as not to dirty his cuffs). The order and selection of colors was chosen after completing several small studies. In *Homage to the Square, "Festive,"* Cadmium Yellow Deep is the dominant and central color, meticulously listed on the back of the painting (center to edge), along with Cadmium Yellow Medium, Yellow Ochre Pale and Optical Gray #3 Cool. The work emphasizes rectilinear shapes of strong, flat color in progressively smaller forms calculated to illustrate his theories of how changes in placement, shape, and light influence and alter color. The work also articulates his lifelong commitment to absolute order based on mathematical proportion, balance and unity, leading him to oppose what he perceived as the chaotic freedoms of Abstract Expressionism.

Albers continued the series *Homage to the Square* until his death. Fascinated by the ambiguities of color and spatial perception, he engages his audience in a dynamic relationship with the works, based on continual surprise and discovery.

—SARAH SCHLEUNING

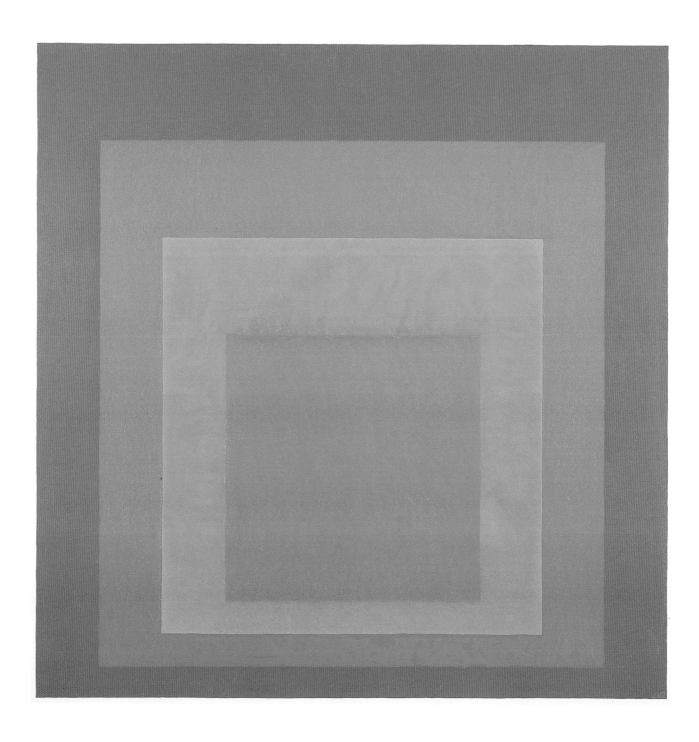

RICHARD ANUSZKIEWICZ
(Born 1930, Erie, Pennsylvania)
Magenta Squared (271), 1969
Liquitex on canvas
36 x 36 inches (91.4 x 91.4 cm)

Acquired by Dr. John and Rose M. Shuey
through Sidney Janis Gallery, New York,
New York, 1969

RICHARD ANUSZKIEWICZ

Richard Anuszkiewicz came to critical notice in 1965, when he was included in the milestone exhibition that brought him international recognition—*The Responsive Eye* at the Museum of Modern Art. Anuszkiewicz was associated with a new type of abstraction known as Color Field Painting or Post-Painterly Abstraction, marked by an emphasis on large scale, unmodulated color, clean edge, and "all-over" design. The new painting addressed the expressive interactions of pure color and shape alone; it was devoid of all literary content and other outside references. Anuszkiewicz's paintings were further linked to the sixties abstraction of Frank Stella, Kenneth Noland, and Ellsworth Kelly. Known as Hard-Edge Painting or Op Art, it cultivated clean-cut geometric form, saturated color, and an exceptional visual liveliness. Its essential character was an elaboration of an earlier tradition of abstraction that was developed at the Bauhaus in Germany and espoused by Josef Albers, with whom Anuszkiewicz had studied at Yale University.

Magenta Squared and *Untitled* of 1969 are vintage examples of Anuszkiewicz's contributions to modernist painting. With identical squared dimensions of three-feet, they were conceived by the artist, as were his other paintings at the time, as a form of collage produced with Liquitex, the brand name for a high viscosity, heavy body, water-based acrylic with a consistency similar to oil paint. Appearing on the market in 1963, Liquitex was a new medium with special properties Anuszkiewicz found appealing.

Typically, Anuszkiewicz first applied underpaintings of Liquitex paint to each canvas: a ground of magenta for *Magenta Squared* with a centered orange lozenge tangential to the framing edge, and a light blue ground for *Untitled* that was superimposed with five vertical bars, each a stack of five squares in different colors. The geometric and straightedge striations of color that strike the eye in both paintings are overlays of Liquitex strips that Anuszkiewicz adhered to the underpainted grounds. When Liquitex medium is added to acrylic, durable films of color can be made. Anuszkiewicz cut out his strips from such films. To create the quadrants for *Magenta Squared*, for example, he painted four Liquitex squares in mustard, light teal, light blue, and gray. With a penknife, he then cut out squared bands of varying widths in each of the colors, which he meticulously applied to the original canvas to give the impression of four concentric squares. Likewise in *Untitled*, the five stacks take their final visual character from the application of orange strips of Liquitex over the underpainted squares.

Anuszkiewicz chose Liquitex to facilitate an unusual form of collage painting. His textured surfaces also lend depth to color and help dematerialize literal surfaces into an appearance of pure, colored light. The reflected light emitted from his abstract shapes is iridescent and shimmering.

Through his color contrasts, each of which is calibrated to the same visual weight, the eye is made to dart while at the same time it is anchored by geometric shape. There is a contradiction of flatness and depth that the eye and mind cannot resolve, as evidenced in the flat color in the four squares of *Magenta Squared* that wrestles with the illusion of receding space induced by the concentric squares. The eye can see the orange lozenge as a unified form and as it fractures into allegiance with each of the four squares. The diminishing widths of the color band in both paintings also create a sense of wavering form. What fools the eye the most is what appears to be a shift of color. Each of the color strips in the four squares of *Magenta Squared* appears to change color. The shift is a function of the various underpaintings and the changes in perception they produce. The concentric gray bands of the lower-left square, for example, strike the eye as different in color as they cross over the underpainted orange lozenge and the magenta ground.

In expressive terms Anuszkiewicz sets order and disorder into a single system: geometry and logical progression are amalgamated with oscillating light and retinal confusions. We catch ourselves attempting to resolve these visual dissonances, but to no avail. That we cannot leads to the heart of the matter: Anuszkiewicz's poetry of radiant indeterminacy.

—RICHARD H. AXSOM

RICHARD ANUSZKIEWICZ
(Born 1930, Erie, Pennsylvania)
Untitled (272), 1969
Liquitex on canvas
36 x 36 inches (91.4 x 91.4 cm)

Acquired by Dr. John and Rose M. Shuey
through Sidney Janis Gallery, New York,
New York, 1969

JEAN ARP
(Born 1887, Strasbourg, Germany;
died 1966, Basel, Switzerland)
Seuil aux créneaux végétaux, 1959
Edition 4 of 5
Polished bronze
28 1/2 x 17 3/4 x 4 inches
(72.4 x 45.1 x 10.2 cm)
Signed on underside: "Arp 4/5"

Acquired by Dr. John and Rose M. Shuey
through Sotheby's, New York, New York,
1985

CITATIONS
Eduard Trier, *Jean Arp Sculpture:*
His Last Ten Years (New York: Harry
N. Abrams, Inc., 1968), pp. 26 (illus.),
111.

JEAN ARP

Jean (Hans) Arp was one of the major figures to emerge from the Dada movement that formed in Zürich during the First World War. Working in a wide variety of media throughout his long and influential career—including reliefs, collages, drawings, tapestries and sculptures—Arp's works are based on his desire to create essential, elemental forms and embody his wish that his art "fit naturally in nature." The career of Jean Arp is characterized by whimsy, poetry and an inexhaustible search for new forms.

Arp studied at the Strasbourg School of Arts and Crafts in Weimar from 1905 to 1907 and the Académie Julian in Paris in 1908. Although Arp participated in a number of significant exhibitions in Germany and Switzerland following his studies, including the second Blaue Reiter exhibition in Munich in 1912, Arp's mature career did not begin until after the outbreak of World War I when he moved to Zürich in 1915 and joined in the founding of the Dada movement. Together with other exiles such as the German writer Hugo Ball, the Romanian poet Tristan Tzara and the German painter Hans Richter, Arp helped launch a radical anti-establishment movement that would spread across Europe in response to the horrors and irrationalities of the war. In Zürich, Arp was a frequent contributor of abstract illustrations and humorous poetry to the Dada movement's many publications such as *Cabaret Voltaire*, *Dada* and *391*, and produced some of the Dadaists' most significant works, including abstract biomorphic wood reliefs and influential experiments with torn paper collages created by chance arrangements. Arp later looked back on this period and remarked that the inventive disorder of Dada and the works they created intended "to destroy the swindle of reason perpetuated on man in order to restore him to his humble place in nature."

By 1930 Arp turned to creating sculpture and found himself aligned with the practitioners of the Surrealist movement in Paris who explored chance, abstraction and the creative unconscious. Arp executed freestanding sculptures in terra-cotta, marble and bronze, and insisted that rather than "abstractions," his sculptures were "concretions" or generations of a natural form, a distinction that emphasized the additive (rather than reductive) manner in which Arp initially modeled his sculptural forms in clay or plaster. Arp's visual vocabulary during this fertile period is expressed in works that evoke torsos, birds, plants and other elementary organic, human and animal-like forms.

The stunning polished bronze Arp sculpture in the Shuey Collection is from the last decade of the artist's career, executed shortly after an important retrospective of his work was presented by the Museum of Modern Art in 1958. *Seuil aux créneaux végétaux* exemplifies Arp's innovations in sculpture and harkens back to his early experiments with torn paper collages and woodcut relief. Standing two and a half feet high from its base, this work gives three-dimensional form to Arp's influential two-dimensional works and embodies many components of his unique visual language. An assertive, upright form, *Seuil aux créneaux végétaux* reads as a detached relief, liberated from its two-dimensional plane. Punctuated by areas of cut out shapes, *Seuil aux créneaux végétaux*'s poetry of solids and voids create ambiguous elementary forms that read as both organic and geometric. The work's enigmatic title—which translates as *Threshold with Plant Crenellations*—further points to Arp's interest in giving form to elemental visions of life itself. Part of a series of similarly titled sculptures, Arp viewed these works and the perforations in their forms as organic passages to new vistas not of this world.

—IRENE HOFMANN

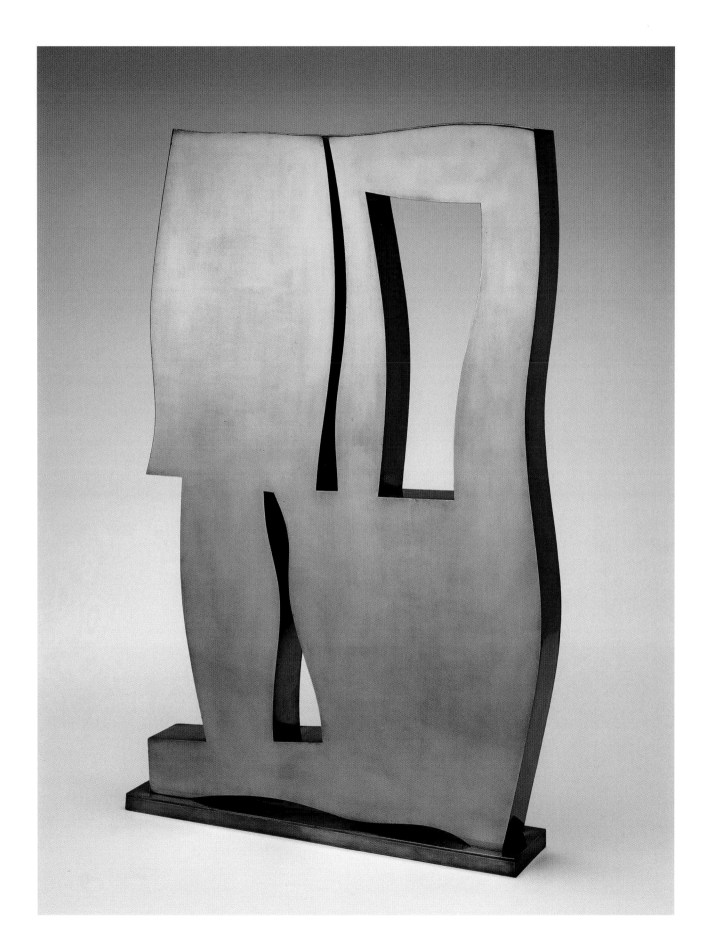

JO BAER
(Born 1929, Seattle, Washington)
Untitled, 1968-1969
Oil on canvas
72 x 72 inches (182.9 x 182.9 cm)
Signed verso: "Jo Baer 68-69"

Acquired by Dr. John and Rose M.
Shuey from Sotheby Parke Bernet, Inc.,
New York, New York, 1980

ADDITIONAL PROVENANCE
Collection of Carter Burden, New York,
New York
Noah Goldowsky Gallery, New York,
New York

EXHIBITION HISTORY
Jo Baer, Whitney Museum of American
Art, New York, New York, May–July
1975

CITATIONS
Jo Baer, Exh. cat. (New York: Whitney
Museum of American Art, 1975), cat.
no. 13.

JO BAER

Jo Baer, born Josephine Gail Kleinberg, is one of the few female artists recognized for her pioneering presence among the generally male, Minimalist movement of the 1960s. Like her friends and fellow proponents of the style—Donald Judd, Carl Andre, Dan Flavin—Baer applied a cerebral, almost ascetic approach to creating her systematic, abstract work. Unlike her peers, however, Baer did not remain true to the Minimalist ethos.

In 1975, Baer abruptly retrenched. She renounced abstract painting altogether and dramatically reconfigured her approach to making art. Baer began to practice "radical figuration," an approach to painting she characterizes as having "no pre-eminence of image or space," but in which figurative imagery is undeniably present. For this reason alone, *Untitled* stands not only as a prototypical minimalist abstraction but as important evidence of a voice that is no longer heard—if one that silenced itself. That this painting is also as a stellar example of Baer's work only increases its aura of rarity.

Before repudiating abstract or non-illusionistic art, which she claimed in 1983, was "nearly meaningless," Baer counted prominently among the New York art world. She studied art at the University of Washington, Seattle, but received her degree in 1949 in Biology. In 1950, she moved to New York and worked in the Graduate Faculty in Physiological Psychology at the New School in Manhattan until 1953. Her study of Gestalt theories of perceptual psychology involved examining the brain's reaction to certain colors and patterns and the way "concepts like squareness, roundness, and so on, previously thought to be generalized or abstract, are considered the foundation of perception." Though she was then painting in an Abstract Expressionist style, these studies clearly influenced her, and were later expressed in the work for which she is best known.

Around 1960 Baer met Sol LeWitt and Donald Judd and in 1964, Dan Flavin included her as one of the *Eleven Artists* in an important exhibition he organized. Baer joined this family of artists who were dedicated to dismantling what they understood to be traditional hierarchies among painting and sculpture in favor of creating a new language that blurred such distinctions and divisions. Their more "conceptual" relationship to producing art—creating a visual statement in which the individual thought, philosophy or psychological intent that went into making the work is considered as significant as the resultant object—clearly appealed to Baer's analytic, intellectual approach.

Untitled is representative of this drive and typifies a series she started in 1968 in which she began to emphasize the relationship of the frame to the picture plane. In these works, the optical and physical properties of the painting's surface initiate the viewer into a voyage of perceptual discovery. Not just a painting, Baer's six-by-six foot object—an expanse of white canvas banded at the edges by a thin ribbon of warm brown paint, which is in turn contained by stripes of black pigment—is also an empty vessel beckoning tranquil observation. The soothing white interior seduces while the vibrating edges entice.

While the direct physical relationship of the body to the object was an essential tenet of Minimalism, Jo Baer's unique contribution was to expand its relationship to self-awareness by insisting on a physiological as well as physical engagement. Though she now regards this type of work as evidence of the "deep-set pessimism . . . of the high art of the '60s," *Untitled* might properly offer today's viewer an untrammeled oculus into Baer's optimistic goals for art in the 1960s.

—JEFFREY D. GROVE

ANTHONY CARO
(Born 1924, New Malden,
Surrey, England)
Coda, 1970-1971
Steel, painted brown
21 1/2 x 54 x 87 inches
(54.6 x 137.2 x 221 cm)

Acquired by Dr. John and Rose M. Shuey
through Sotheby Parke Bernet, 1976

ADDITIONAL PROVENANCE
David Mirvish Gallery, Toronto,
Ontario, Canada

EXHIBITION HISTORY
Anthony Caro, David Mirvish Gallery,
Toronto, Ontario, Canada,
June 12–July 31, 1971

CITATIONS
Dieter Blume, *Anthony Caro: Catalogue
Raisonné Vol. III, Steel Sculptures
1960-1980* (Köln: Verlag Galerie
Wentzel, 1981), p. 210 (illus.).

Anthony Caro, Exh. cat. (Toronto: David
Mirvish Gallery, 1971), p.3 (illus.).

ANTHONY CARO

After a brief but transformative sojourn in the United States in 1959, Anthony Caro abandoned the small scale, modeled figures he had been developing in the 1950s and began to construct the abstract, welded steel sculptures that have been his métier ever since. Before his cathartic experience in America, London-born Caro had studied at Christ's College, Cambridge (where he received a degree in engineering), Farnham School of Art, Farnham, Regent Street Polytechnic and the Royal Academy Schools in London. He also worked as an assistant to the renowned mid-century British sculptor, Henry Moore, from 1951-53.

During his career-changing visit to the U.S., Caro renewed his acquaintance with critic Clement Greenberg and met non-representational artists Robert Motherwell, Kenneth Noland, David Smith, and Anne Truitt, among others. Upon his return to England, Caro collected an inventory of scrap metal parts, purchased welding equipment, and assembled his first abstract sculpture. Describing this period of rapid, radical change after his return, Caro observed, "There's a fine-art quality about European art, even when it's made from junk. America made me see that there are no barriers and no regulations. . . .There's a tremendous freedom in knowing that your only limitations in a sculpture or a painting are whether it carries its intentions or not, not whether it's 'Art.'"

Like many artists rebelling against the Abstract Expressionism of the 1950s, Caro wanted his sculpture to look straightforward, not precious: "No art props, no nostalgia, no feelings of the preciousness associated with something because it's old or bronze, or it's rusty, encrusted, or patinated. So I just covered it with a coat of paint. I used brown or black paint and the sculptures looked more as if they were destined for a locomotive factory than an art gallery." Through the 1960s, Caro developed and refined a sculptural mode characterized by horizontal extension, industrial metal materials, non-objectivity, absence of base or pedestal, painted surfaces, and a bold, affirmative spirit. His low-lying *Coda*, from the first decade of his audacious, new style, unfolds across the floor in a free, open-ended manner. Despite its heavy material—steel plates and I-beams—*Coda*'s metal components abut one another in cantilevered, hovering positions that nimbly defy gravity. Its overall form, from the point of view pictured here, descends to the arrow-shaped trapezoid in the foreground. To either side two I-beams, flanking a central, inclined, trough-like element, appear to float unsupported in space. Since "coda" refers to the concluding section of a musical score, the arrow form becomes the point toward which the assorted components of the work converge, while the sculpture's rich brown hue reiterates the summary, weighty heft associated with a musical finale.

Since Caro's *modus operandi* in composing sculpture is to improvise from a stockpile of parts (in 1967 he had a cache of thirty-seven tons of unused steel from David Smith's estate shipped to Great Britain), *Coda*'s sprightly articulation hinges on the unity and interdependence of its segments: the grounded trapezoid and perpendicular steel plate at the right form two stable poles fluently bridged by several intervening elements.

Though frequently connected to the reductive, international Minimalist style that dominated the mid-1960s art world, and though his sculptures are undeniably spare and distilled like much Minimalist art, Caro's distinctively pictorial style and suggestive titles seem to defy the cool, impersonal aesthetic and monolithic gestalt of classic Minimalism.

—DENNIS ALAN NAWROCKI

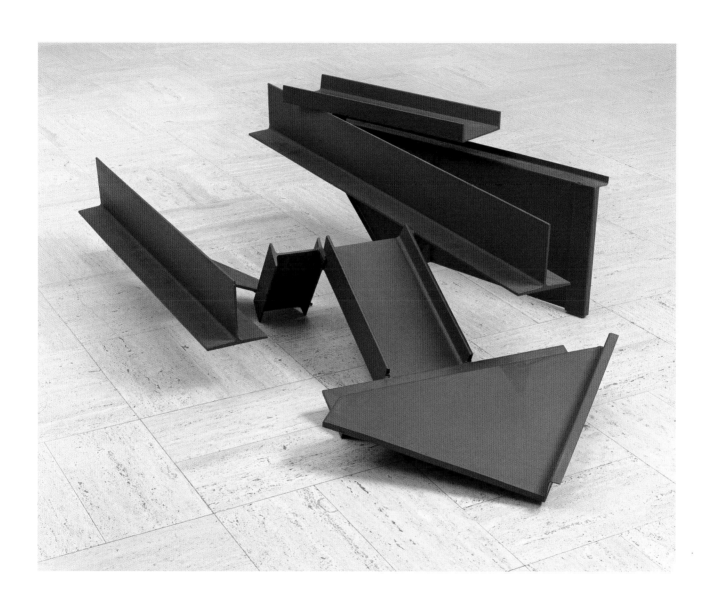

RICHARD DIEBENKORN
(Born 1922, Portland, Oregon;
died 1993, Berkeley, California)
Untitled, 1980
Gouache on paper
38 x 25 inches (96.5 x 63.5 cm)
Signed lower left: "R.D. 80"

Acquired by Dr. John and Rose M. Shuey
through M. Knoedler & Company, Inc.,
New York, New York, 1980

EXHIBITION HISTORY
Richard Diebenkorn, M. Knoedler &
Company, Inc., New York, New York,
November 7–December 2, 1980

CITATIONS
Richard Newlin, *Richard Diebenkorn:
Works on Paper* (Houston: Houston
Fine Art Press, 1987), p. 161 (illus.).

Richard Diebenkorn, Exh. cat. (New
York: M. Knoedler & Company, Inc.,
1984), unpaginated (illus.).

RICHARD DIEBENKORN

California artist Richard Diebenkorn moved through three phases in his career: Abstract Expressionism, figuration, and finally a series of majestic non-figurative abstractions known as the Ocean Park paintings. Though untitled by the artist, the works known as *Untitled* and *Untitled #14* are both from Diebenkorn's Ocean Park series, a group of drawings, paintings and gouaches the artist worked on for over twenty years, from the mid-1960s until the late 1980s. Named after the area in Santa Monica, California, where he lived, the series was inspired in part by driving up and down the Pacific Coast Highway, where Diebenkorn was struck by the parallels between grass, highway, beach, sky, and ocean. Many works from the Ocean Park series are larger-than-life sized (90-100 inches), and employ a personal vocabulary of light-filled color planes within a softly drawn architectural scaffolding.

After serving in World War II, Diebenkorn studied at the California School of Fine Arts in San Francisco, where both Clyfford Still and Mark Rothko taught. In 1954 he turned from abstract to figurative work while in close contact with California painters David Park and Elmer Bischoff. In 1967, following his relocation to Santa Monica, Diebenkorn moved back to abstraction with the Ocean Park series. Referring to representational work, the artist said, "The figure exerts a continuing and unspecified influence on the painting as the canvas develops. The represented forms are loaded with psychological feeling. It can't ever be just painting." With the Ocean Park paintings, he attempted to define space, mood and light without the figure, searching for a "total artistic freedom without any recognizable imagery."

Though abstract works, both gouaches conjure associations of landscape: the dominant cerulean blue of *Untitled #14* recalls the Pacific Ocean, and its panels of green, gold and salmon suggest patches of grass, sun, and sky, while the vaporous gray of *Untitled* might evoke a cloud-filled, hazy sky as seen through a window. In these works Diebenkorn skillfully attains a sense of equilibrium between formal opposites: drawing and painting, closed and open forms, tautness and diffusion, angles and curves, the linear and the gestural.

In *Untitled #14*, for example, the work is divided into a set of boxed areas banded by straight black edges, but these demarcations are balanced by the presence of diagonal vectors, one in the lower left region of the work and a second that is part of a white triangle above a yellow rectangle. Paint is applied in thin, diluted washes of multiple layers, with visible painterly brushstrokes in a finely modulated range of blue, white and pink.

Untitled is structured by several bold intersecting black lines, straight and curved, which both limn the canvas into smaller, irregularly shaped compartments and suggest boundless expansion beyond the space of the frame. Here, too, rigid edges are counterpoised with broad expressive brushwork in several gradations of white and frosted gray.

These works are clearly structured, and Diebenkorn spoke about his intention to get everything right: "By that I mean everything," he said, "color, form, space, line, composition, what all this might add up to—*everything* at once." At the same time, though, his paintings can appear roughly hewn, and Diebenkorn also talked about his enthusiasm for the element of surprise in the artmaking process. He commented that he was "always swinging back and forth between pared-down simplicity and an attempt to hold on to the incidentals," and that he hoped for "an element of surprise—a break in the system." This attraction to the possibilities engendered by improvisation and accident may also have been an influence of the spontaneous, unplanned working methods of the Abstract Expressionists, and we can see traces of Diebenkorn's "incidentals" in these works. In *Untitled #14*, the slate blue and pink colors appear to have been mixed on the canvas, in the midst of painting, and in *Untitled* a curving line in the work's lower right corner has been scumbled over but remains visible.

With *Untitled* and *Untitled #14*, Diebenkorn has distilled the landscape vistas of Ocean Park into interlocking luminous planes, creating subtle abstractions that seem suffused with California light. All elements of the pictures are held in graceful equipoise. Understated and serene and yet maintaining a balance of forces, these works exemplify Diebenkorn's desire to convey "a feeling of strength in reserve, of tension beneath calm."

—LISA PASQUARIELLO

RICHARD DIEBENKORN
(Born 1922, Portland, Oregon;
died 1993, Berkeley, California)
Untitled #14, 1983
Gouache, acrylic and crayon on paper
38 x 25 inches (96.5 x 63.5 cm)
Signed lower right: "R.D. 83"

Acquired by Dr. John and Rose M. Shuey
through M. Knoedler & Company, Inc.,
New York, New York, 1984

EXHIBITION HISTORY
Richard Diebenkorn: Recent Work,
M. Knoedler & Company, Inc., New York,
New York, May 12–May 31, 1984

CITATIONS
Richard Newlin, *Richard Diebenkorn:
Works on Paper* (Houston: Houston
Fine Art Press, 1987), p. 217 (illus.).

Richard Diebenkorn, Exh. cat. (New
York: M. Knoedler & Company, Inc.,
1984), cat. no. 20 (illus.).

JIM DINE

With its aggressively worked surfaces and attached objects, *The Heart at Sea (in a Non-Secular Way)* is a reminder of Jim Dine's artistic formation in earlier mid-century contexts of Abstract Expressionism and Neo-Dada. Joining ordinary things to expressive fields of paint, Dine joined company in the early 1960s with Jasper Johns and Robert Rauschenberg. These artists wished to reconcile art and life or, in Rauschenberg's words, "to act in the gap between them." This idea was the wellspring for a new sensibility in contemporary art that would be quickly known as Pop art. Dine was one of its central figures. As a painter, sculptor and printmaker, Dine took as themes Tools, Robes, Trees, and Gates, later adding Venus de Milo, Skulls, Birds, and Flowers. One of his best known themes has been Hearts.

Dine's Heart shape, that of the Victorian valentine, is an emblem of both romantic and sexual love. He speaks of its dualistic nature, which combines the concepts of sacred and profane love. But Dine does not see the Heart as fixed in meaning. It shifts in expressiveness as it gathers resonance from its particular stylistic articulation, from Dine's choice of title, and from immediate personal circumstances. Context is everything.

With the highly emotionalized Heart paintings of 1981, Dine declared himself an unabashed expressionist. This shift in his art joined him to a new current of neo-expressionism and to his artistic roots of the later 1950s. In a bravura handling of acrylic paints, he surrounds his monumental Heart in *The Heart at Sea* and nearly inundates it with agitated and sweeping gestures of color. The richly dark palette is streaked with sulphurous oranges and explosions of crimson. Dine's motif is endangered, barely able to assert itself in the turbulence of brushwork and color. Dine force-dried thick applications of acrylic compound with electric heaters. This resulted in cracks and fissures, a "crazing" of the surface that distressed the image. Dine also took corrugated cardboard and stamped the acrylic surfaces of the Heart. The roughened textures suggest a trampled heart and recalls, in the context of the painting's title, an old descriptive phrase about the "wind corrugating the surface of the sea." In truth, *Heart at Sea* is a marine landscape—nocturnal, tumultuous, and mythic.

Dine arranged three conch shells, splashed with blue paint, in a single register across the Heart. Triton, the Greco-Roman demigod of the sea was often visualized holding a trumpet made of a conch shell, sounding it on triumphal occasions. Dine's use of the conch shell to allude to the sea, however, is ironic. There is no cause for joy, only its brooding opposite. The conch shell was also an object used in seventeenth-century *vanitas* still-life paintings, taking its place beside the multitude of candles, hourglasses, wilting flowers, and skulls to remind the devout of the brevity of life and the inevitability of death. Does the somber cast of Dine's painting spell imminent loss? Anything "at sea" is without physical or psychological bearings. If Dine's Heart is at sea "in a non-secular way," the forfeit may also be spiritual. But does the symbolic fact of three conch shells lend hope, a redemptive note—strengthened by the strip of wood attached to the far right of the canvas that helps anchor the composition and steady the emotional currents of paint?

All of the Heart paintings of 1981 made references to troubled landscapes of the mind. They were inspired by Dine's deep concern over the fate of a close friend who was recovering from a severe mental breakdown. Dine felt the paintings were a way of exorcising his "dear friend's demons." He also stated that they came "from that part of the body that is one's 'studio' of the soul." That "studio" is the human heart, and Dine's is a compassionate one.

—RICHARD H. AXSOM

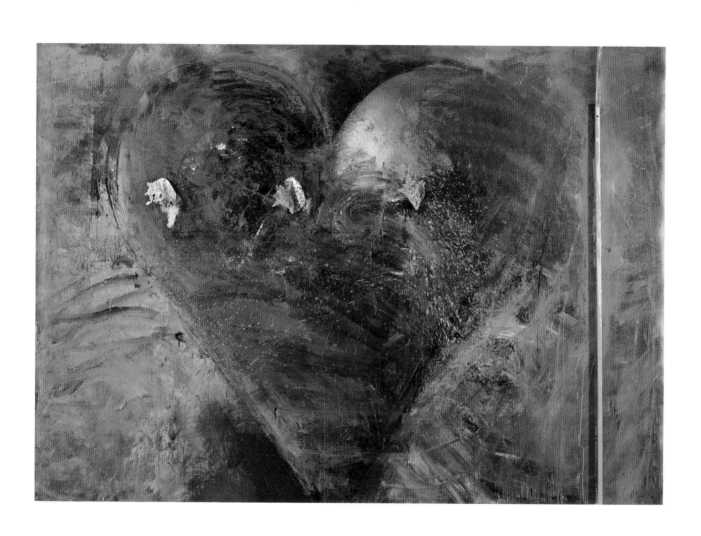

JEAN DUBUFFET
(Born 1901, Le Havre, France;
died 1985, Paris, France)
Promenade à deux, 1974
Vinyl on canvas, matte Cryla varnish
77 7/8 x 51 1/2 inches
(197.8 x 130.8 cm)
Signed lower left: "J.D. 74"
Signed verso: "Promenade à deux
J. Dubuffet 74"

Acquired by Dr. John and Rose M. Shuey
through The Pace Gallery, New York,
New York, 1976

EXHIBITION HISTORY
*Jean Dubuffet Recent Paintings:
Paysages Castillans Sites Tricolores*,
The Pace Gallery, New York, New York,
September 20 – October 18, 1975

CITATIONS
*Jean Dubuffet Recent Paintings:
Paysages Castillans Sites Tricolores*,
Exh. cat. (New York: The Pace Gallery,
1975), unpaginated (illus.).

JEAN DUBUFFET

One of the most unequivocally anti-traditionalist artists to emerge in Europe after World War II, Jean Dubuffet launched a wide range of subjects and a plethora of styles over the course of a long and prolific career. Born in LeHavre, Dubuffet studied art intermittently, pursued an art career on and off for a number of years, and managed his wine business. Finally committing himself to painting in 1942, in the midst of the Nazi occupation of France, he premiered in Paris in 1944 a notable series of portraits inflected by the naiveté of children's art, perhaps as a deliberate rejection of the idealized aesthetic promulgated by Germany's Nazi regime. Declaring himself an advocate of *Art brut* (raw art), he espoused and voraciously collected the art of children, the insane, and the untrained. (The collection, totaling over 5000 items, is housed today in the Collection de l'Art Brut in Lausanne, Switzerland.)

In 1951, Dubuffet insisted that, "Our culture is an ill-fitting coat—or at least one that no longer fits us." In the first two decades of his career, Dubuffet's contrary views were vividly delineated in a number of series he variously titled *Corps de dame* (1950-52), *Célébration du sol* (1957-59), *Texturologies* (1958-60), and *Paris Circus* (1961-62).

Then, in 1962, Dubuffet serendipitously discovered, while talking on the telephone, what was to become a new and obsessive vocabulary for the next twelve years. As he spoke, he doodled with a ball point pen (a relatively new invention) and quickly became intrigued by its capacity to create a continuous uniform line free of the stops and starts of ink or paint. Dubuffet subsequently devised a sinuous network of jigsaw-puzzle-like forms that obscured distinctions between figure and surroundings, and adopted the tricolor palette of ball point pens of the era—black, blue, and red. Once expanded from their origins as paper doodles to large-scale canvases, Dubuffet dubbed these dense, interlocking compositions *L'Hourloupe*.

The *L'Hourloupe* painting *Promenade à deux* (which translates as *Two Persons Walking*) executed in vinyl on canvas to mimic the flat, smooth surface of its ball pen source, presents two men walking toward the viewer. Though similarly attired in suits and ties or cravats, each differs from the other physically (with the exception of their bald pates) and in personality. The dapper, wasp-waisted fellow on the left, arms dangling stiffly beyond his body, complements the seemingly more genial, animated, but perhaps overbearing friend at the right. The latter seems to be gesturing toward the observer while cocking his head to the left in friendly, vigorous greeting. His broad head and grinning visage distinguish his persona from the tapering skull, startled expression, and rigid legs of his companion. Though apparently quite singular as individuals, their *promenade à deux* implies that they are at least companionable opposites.

Like many of Dubuffet's *L'Hourloupe* compositions, the splotchy, light-and-dark patterning of the figures and background suggests vestigial references to the academic technique of modeling from light to dark. Nevertheless, both men seem as flat as the path and landscape that rise up behind them.

Dubuffet defined the meaning of *L'Hourloupe* as "a word whose invention was based upon its sound. In French, these sounds suggest some wonderful or grotesque object or creature, while at the same time they evoke something rumbling and threatening with tragic overtones." The characters and mood of the painting embody both of these ideas.

—DENNIS ALAN NAWROCKI

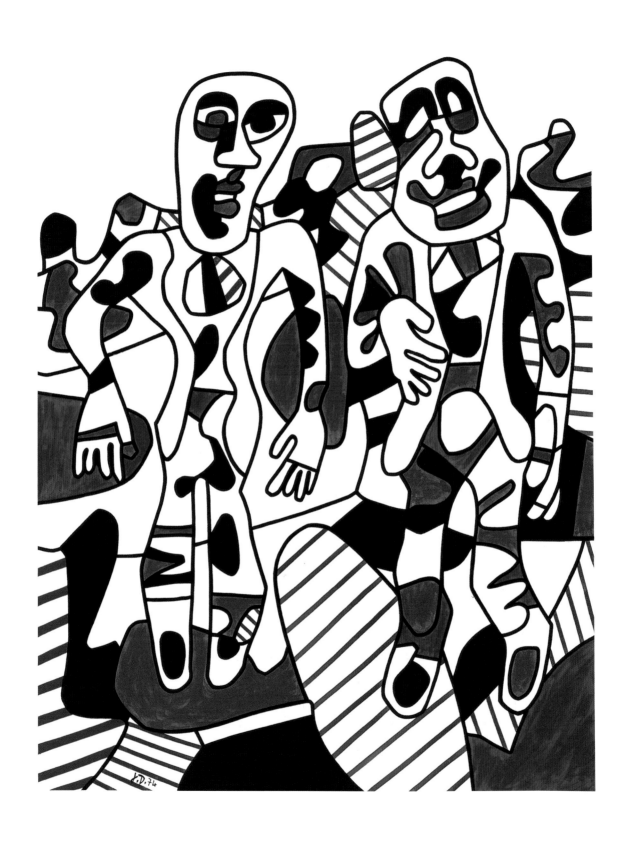

SAM FRANCIS
(Born 1923, San Mateo, California;
died 1994, Santa Monica, California)
Untitled, 1985
Acrylic on paper
41 3/8 x 29 1/2 inches
(105.1 x 74.9 cm)
Signed verso: "Sam Francis 1985"

Acquired by Dr. John and Rose M. Shuey
through Christie's, New York, New York,
1994

SAM FRANCIS

Though Sam Francis is best known for his vibrant spatterings of color, an equally important part of his painterly vocabulary is the blank white space that he left around his corpuscular islands of fiery hues. Located near the center or at the edges of the canvas, the artist preferred to see this blank area not as a void or vacuum but as a Zen-like region that, though physically empty, was limitless and charged with energy. Francis began reading Carl Jung in the early 1970s, and was influenced by the Swiss psychologist's idea that the nature of the universe is dynamic and ever-changing, in an ongoing creative process. "To constantly live in chaos," Francis wrote, "is to live within perfection." His working method was accordingly fluid and somewhat chaotic. He painted "automatically"–flinging and spilling paint onto large canvases without conscious planning or premeditation–melding the spontaneous technique of Abstract Expressionist painters such as Jackson Pollock with the richly saturated lyrical colors of 1960s open-form Color Field Painters such as Morris Louis and Jules Olitski.

Francis began making art in San Francisco's Veteran's Administration Hospital while recuperating from spinal injuries suffered as a fighter pilot during World War II. Lying flat on his back and nearly immobile in a body cast, he was struck by the play of light, color and shadow across his ceiling and in the sky over the Pacific Ocean. Enrolling at the University of California at Berkeley, Francis received his M.F.A. in 1950 before moving to Paris, where he would spend the next twelve years. Deeply affected by the work he saw in museums there, especially by the use of color in Monet and Matisse, Francis commented that he wanted to retain the lush colors of Monet's Waterlilies series while abandoning representational subject matter. The artist worked first in monochrome and then began to paint abstract, cell-like patterns of bright primary colors, often organized in a rough grid or other geometric pattern.

In this smaller work from 1985, Francis covers the paper surface with the jewel-like colors of the Byzantine mosaics that he loved. Patches of ruby red, deep violet, iridescent orange and lime green are juxtaposed with areas of inky black, and thick patches of color interlaced with tiny drips and thin skeins of flung paint. Affected by Jung's writings on alchemy, Francis conceptualized painting as a process that involved a transformation of the ancient elements of earth, air, water and fire. Believing color to be the "real force in nature and in the psyche," he declared "red and gold, blue and purple, and green" to be the "five basic colors," with red and gold signifying burning light, blue and purple standing for the ocean and sky, and green representing foliage and organic forms. Despite the dense mottled mass at the center of *Untitled*, bits of luminous white appear through the color and in the work's four corners, lending the painting a sense of the airy, seemingly weightless openness for which Francis has become known.

—LISA PASQUARIELLO

BARBARA HEPWORTH
(Born 1903, Wakefield, England;
died 1975, St. Ives, England)
Square Forms, 1962
Edition 4 of 9
Bronze
12 3/4 x 7 1/2 x 3 1/2 inches
(32.4 x 19.1 x 8.9 cm)
Numbered on side of base: "4/9"

Acquired by Dr. John and Rose M. Shuey
through Christie's, New York, New York,
1995

ADDITIONAL PROVENANCE
Private Collection
Galerie Chalette, New York, New York

CITATIONS
A. Bowness, *The Complete Sculpture
of Barbara Hepworth 1960-1969*
(London: Praeger, 1971), cat. no. 313.

BARBARA HEPWORTH

Barbara Hepworth initiated a radical new approach to European abstract sculpture in the 1930s. Hepworth's signature work consists of smoothly polished biomorphic shapes carved directly from stone, often punctuated by an ovoid cavity. This piercing was a major contribution to the sculptural vocabulary at the time and allowed a new understanding of possibilities in modern sculpture. Hepworth recalled, "When I first pierced a shape, I thought it was a miracle. A new vision was opened."

Along with her friend Henry Moore, Hepworth attended the Leeds School of Art before moving to the Royal College of Art, where she graduated in 1924. Though she lost the prestigious Rome Scholarship to John Skeaping, she married him and traveled to Italy, where she studied Romanesque and early Renaissance sculpture and architecture. Hepworth's other interests included Egyptian, Cycladic and Archaic Greek sculpture, which are reflected in her carvings of the late 1920s. In 1932, after divorcing Skeaping, Hepworth married Ben Nicholson, with whom her work shared an affinity and who is today acknowledged as one of the leading artists of the twentieth century.

Early in their life together, the two visited and became close to Picasso, Braque, Brancusi, Arp and especially Mondrian, all of whom shared an interest in formal purity. In 1933, Hepworth and Nicholson joined Abstraction-Création and were founders of Unit One, a group of architects, painters and sculptors committed to Constructivism or Surrealism. Throughout the 1930s and 1940s, Hepworth eschewed the figure and refined the principles of geometric abstraction in hundreds of exquisitely carved sculptures. Her modestly scaled works were thoughtful expositions on the balance of light and mass. Equilibrium was paramount for Hepworth, whether carving a contoured horizontal or a vertical form.

In the late 1940s and 1950s, Hepworth's work began to increasingly reference the figural as it became more monumental and upright. Hepworth viewed this development as the product of her increasing interest in the relationship of the human form to architectural spaces; at the same time, she began to receive a number of large, outdoor public commissions. Perhaps as a result, in 1956 Hepworth began to work in metal, a choice some viewed as a negation of her previous truth to materials, while others viewed it as a sign of increased confidence and desire to create on a larger scale. Though it measures less than thirteen inches in height, *Square Forms* is evidence of this.

Square Forms likely originated as a model for a larger sculpture, *Square Forms with Circles*, 1963, to which it is nearly identical. The 1963 work is eight times larger, however, and its uppermost square has a circular depression cut into one side and a circle incised on the other. The works are unusual for other reasons. The intertwined geometric and planar surfaces clearly recall the paintings and reliefs of Ben Nicholson, while Hepworth's own works of this period were generally more organic. Also significant is the manner in which the smaller sculptures were produced (this is one of an edition of nine). Bronze sculpture of a similar scale is usually cast whole. *Square Forms*, however, is an assembled work.

Comprising seven elements projecting from a rectangular column screwed to a square base, the core of the cluster is held by a vertical rectangle secured in the column by a mortise joint. Other squares are stacked up and displaced upward or to the side by being set into cuts made into the other slabs. In addition, this is one of the few multiple editions of a single work Hepworth issued, and each one is individually constructed. Unique in many respects despite its serial nature, *Square Forms* marked a point of departure in Hepworth's singular career.

—JEFFREY D. GROVE

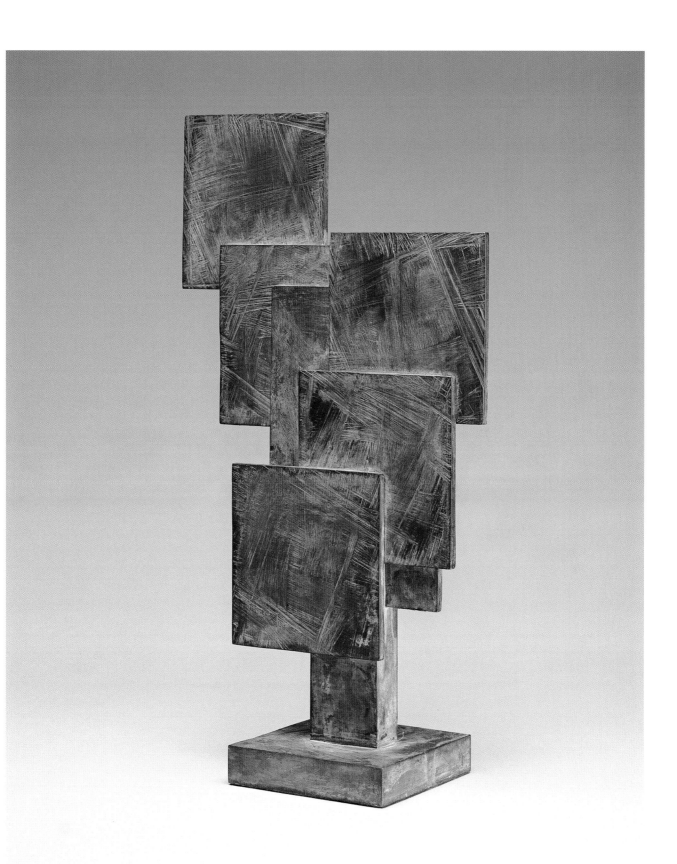

Courtesy of the Estate of Joseph Hirsch and Kennedy Galleries, New York

JOSEPH HIRSCH
(Born 1910, Philadelphia,
Pennsylvania; died 1981,
New York, New York)
Deposition, 1967
Oil on canvas
24 3/4 x 30 3/4 inches (62.9 x 78.1 cm)
Signed lower left: "Joseph Hirsch"

Acquired by Dr. John and Rose M. Shuey
through Forum Gallery, New York,
New York, 1967

EXHIBITION HISTORY
Paintings by Joseph Hirsch,
Georgia Museum of Art, University of
Georgia, Athens, Georgia, March
20–May 1, 1970

Recent Paintings and Drawings,
Forum Gallery, New York, New York,
March 18–April 12, 1969

CITATIONS
Joseph Hirsch, Exh. cat. (Athens,
Georgia: Georgia Museum of Art,
University of Georgia, 1970), p. 38
(illus.).

Recent Paintings and Drawings, Exh.
cat. (New York: Forum Gallery, 1969),
cat. no. 8 (illus.).

JOSEPH HIRSCH

Joseph Hirsch was born in Philadelphia and studied at the Philadelphia College of Art and with Henry Hensche in Provincetown and George Luks in New York. Luks was a member of The Eight, a group of painters at the beginning of the century who took ordinary people and everyday life as their subject. Their work, in turn, helped spawn the Ashcan School of urban realism and the Social Realism of the 1920s and 1930s that focused on the realities of American life, particularly during the Great Depression. Hirsch retained a lifelong focus on social commentary, once responding to a question about his art by saying, "I make cudgels"—evoking the social commitment of artists such as Raphael and Moses Soyer, Ben Shahn, Jack Levine, and Jacob Lawrence, all of whom were his friends.

Painted during the height of United States involvement in the Vietnam War, *Deposition* represents a modern pieta. Hirsch depicts a comrade in the role of the grieving Mary, holding the lifeless body of a soldier who seems paradigmatic of all young men sacrificed on the altar of war. The central image is rooted in the Social Realism of art before World War II, but is also connected to the existential doubt and implicit search for universal meaning in postwar Abstract Expressionism. This is conveyed in the Franz Kline-like painting produced as a backdrop to this scene of existential pondering of the human condition brought about by modern day militarism. The dense black and warm luminous spaces of the postwar modernist background allude to a twentieth-century form of crucifixion, in this context evoking the tension between obscurity and illumination, redemption and despair. Space is suggested by the layering of planes and the figures contained within, rather than through traditional perspective. The central figure stares obliquely into the unfathomable depths, as if contemplating the meaning of death and loss, sacrifice and heroism, the effects of nationalist ideologies, or the role of the individual on the larger stage of history. The scene is contained within a gilded frame that lends it an iconic status while the rust-like patination evokes a gritty industrial world.

During the 1930s, Hirsch was employed by the Works Progress Administration in Philadelphia where he completed murals for the Amalgamated Clothing Workers Building and the Municipal Court. In 1941 he became affiliated with the Associated American Artists Gallery in New York, which also represented the well-known Regionalist artists Grant Wood, John Steuart Curry, and Thomas Hart Benton. During World War II, he worked for Abbott Laboratories, producing artworks to illustrate the war effort and served as a war artist recording events in the South Pacific, Italy and North Africa. After the war he continued his successful career, selling his paintings through New York galleries, working on commissions for corporations, and producing special projects, such as designs for playbills. During the 1960s and 1970s, Hirsch also produced paintings for the U.S. Bureau of Reclamation and was fascinated with the workman and his machinery, often using layered planes to compose his paintings. Barry Schwartz, in 1974, characterized Hirsch's art as "a new humanism."

Hirsch taught at the Art Institute of Chicago, the American Art School, University of Utah, and the Art Students League in New York until his death in 1981. His dramatic and socially observant works have won nearly every major award offered to American artists, but he was proudest of winning First Prize at the New York World's Fair in 1939 for *Whitey Being Told Like It Is*, a painting of a black man sitting at a table with a white man, pounding his fist.

—DORA APEL

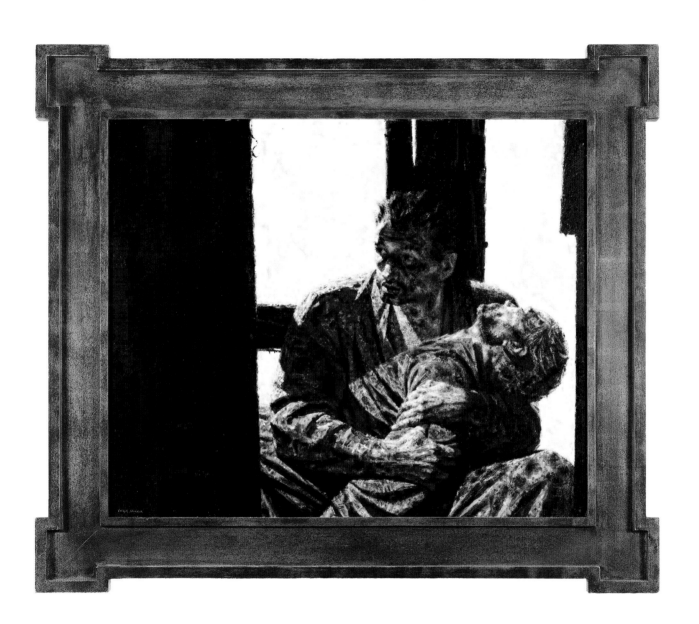

PAUL JENKINS
(Born 1923, Kansas City, Missouri)
Phenomena Veil Over & Under, 1964
Acrylic on canvas
59 1/4 x 39 1/2 inches
(150.5 X 100.3 cm)
Signed lower left: "Jenkins"

Acquired by Dr. John and Rose M. Shuey
through Martha Jackson Gallery,
New York, New York, 1965

PAUL JENKINS

Overlapping wings of color stretch upwards in Paul Jenkins's *Phenomena Veil Over & Under*. As the title suggests, the transparent flowing veils overlap and interact. They invite readings as both abstract forms and as evocations of parts of the physical world.

Born William Paul Jenkins in Kansas City, Missouri, the artist felt an early call to the ministry. This spiritual dimension remained when Jenkins turned to art and theater. He studied at the Kansas City Art Institute, and worked at playhouses in Kansas City, Youngstown, and Cleveland, before taking playwriting classes in Pittsburgh and New York and painting at the Art Students League (1948-1951). In 1953, Jenkins moved to Europe, traveling through Italy, Spain, and Sicily, before settling in Paris, where he remained until the 1960s, when he began dividing his time between New York and Paris.

Dissatisfied with his early attempts at suggesting spiritual reality through figurative art, Jenkins gradually developed transparent veils of luminous color to capture what he saw as the reality of nature—"structures that are eternal and constantly manifest themselves." His aesthetic philosophy was fed by many sources, including the ideas of Gurdjieff, Jung, Goethe, Paul Klee, Zen Buddhism, the occult, astrology, alchemy, and the art of Moreau, Redon, Clyfford Still, Rothko, Sam Francis, and artists whose work was called *art autre* by Michel Tapié (Wols, Michaud, Fautrier, Dubuffet, Mathieu, Hartung, Pollock, and Tobey).

By the 1960s, Jenkins had perfected his method of working. He primes his canvases with a white acrylic undercoat, which both protects the fabric and creates a crucial luminosity that shines through the overlays of thin color shapes. The artist mixes his own intense hues, combining a non-drying, highly viscous acrylic paint manufactured in Germany with an acrylic matte medium. This mixture he thins with water. He pours his paint onto a tilted canvas (unstretched if large), moving it out from puddled areas with a long-handled brush or a dull single-edged ivory knife, taking care that no "mark" of the artist's hand is seen. As he works, Jenkins pauses often to consider the evolving work from all sides, and to view it from the top of a ladder, where he can see the whole without reflections from still-wet surfaces. He "corrects" areas by wiping them free with water and clean cloths. If the color is too dense, he lays down a new granular white veil, which can shine through additional transparent layers of color. The finished work is sprayed with a special matte varnish that preserves the luminosity with no shiny surface. All of this is done "in the moment," which the artist describes by saying that he feels like a medium responding to deep inner guidance.

Inevitably, Jenkins's veil paintings draw comparisons with works by Helen Frankenthaler and Morris Louis. However, Louis and Frankenthaler worked on raw canvas, while Jenkins primes his canvases. Moreover, the compositions of each artist are distinctive. *Phenomena Veil Over & Under*, at five feet in height, is human scale, and more intimate than many of Jenkins's 1960s works, but shares with them the poetically allusive words that follow the initiating "Phenomena." In *Phenomena Veil Over & Under*, the vivid blue, orange, red, green, lavender, and brown shapes move up the canvas with the leisurely pace of clouds, and are equally allusive. One may think of tidal movement, of soaring avian wings, of swirling foliage, of curling smoke trails, even (in the central blue form) of a veiled figure that recalls early drawings that Jenkins made based on Barbara Morgan's photographs of Martha Graham dancing. The shifting allusions of this evocative composition touch our inmost core.

—DIANE KIRKPATRICK

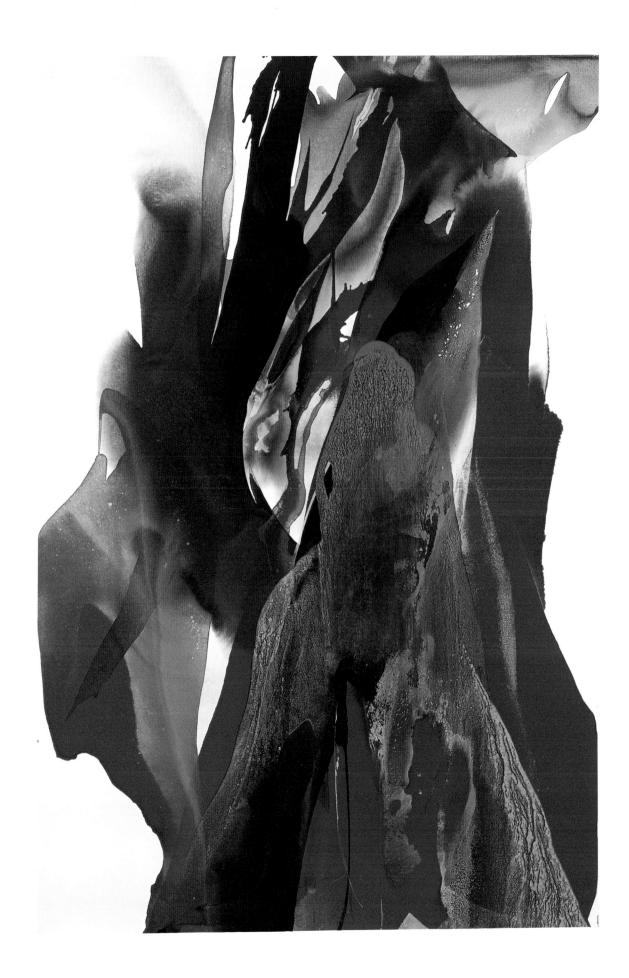

ALFRED JENSEN
(Born 1903, Guatemala City,
Guatemala; died 1981, Glen Ridge,
New Jersey)
Atlantis, Per II, 1965
Oil on canvas
50 x 50 inches (127 x 127 cm)
Signed verso: "Title: 'Atlantis, Per II.'
Size: 50" x 50". Painted in 1965 by
Alfred Jensen"

Acquired by Dr. John and Rose M. Shuey
through Christie's, New York, New York,
1997

ADDITIONAL PROVENANCE
Charles Cowles Gallery, New York,
New York
Daniel Weinberg Gallery, Los Angeles,
California
The Pace Gallery, New York, New York

EXHIBITION HISTORY
Essentials, Charles Cowles Gallery,
New York, New York, September
7–October 2, 1993

ALFRED JENSEN

Emblazoned with brilliant "checkers" of prismatic color, the paintings of Alfred Jensen are hard to categorize, and even harder to decode. Formally related to Hard Edge Abstraction, Op Art and the "sign" phase of Pop Art, his paintings embody mythical meanings that reference, among other fields of knowledge, Peruvian, Mayan and Egyptian calendars and architecture; ancient Chinese and Greek mathematical and numerical systems drawn from the *I-Ching* and Pythagoreanism; physics and astronomy; the color theories of the German writer Goethe and the French theorist Michel Chevreul; and the optics of the prism.

Born to a German-Polish mother and a Danish father, Jensen was raised in Guatemala City and Denmark. After traveling extensively as a seaman, he began his formal art training in California before traveling to Munich to study for a year with Hans Hofmann. During the next twenty-four years, he traveled and studied throughout Europe, North Africa and the United States with his patron, the wealthy art collector Saidie Adler May.

In 1951, already in his late 40s, he established his studio in New York City and positioned himself in the midst of the American vanguard, quickly developing the respect of both the more established artists (he frequently exchanged criticisms with Mark Rothko and Sam Francis, while Donald Judd described him as "one of the best painters in the United States") and a younger generation (one of his most-quoted champions was Allan Kaprow, an artist associated with the performative Happenings of the late 1950s). Jensen had his first one-person show in New York in 1953 and participated in group exhibitions with artists such as Franz Kline, Joseph Cornell, Willem de Kooning and Robert Rauschenberg. His artistic breakthrough occurred in the late 1950s when he abandoned his expressionistic paintings and developed his signature style as a "diagram painter."

Atlantis, Per II is a culminating example of Jensen's early mature style, without the incorporation of numbers and symbols that would characterize his later work. It is one of the few paintings in which he breaks the flatness of the surface and creates an illusionistic space with radiating black and white diagonals. Floating on top of this one-point perspective are three rectangular "checkerboards" with their checkers arranged in a highly systematic and ordered manner. As in most of his paintings, the paint is not mixed.

The title references the legendary continent of Atlantis, which is supposed to have sunk into the ocean. *Atlantis, Per II* (the second of three paintings in this series) was painted the year after Jensen and his wife, Regina Bogat, honeymooned for six months in Europe and Egypt where he pursued his interest in ancient civilizations. Combined with his ongoing research into Mayan architecture and hieroglyphic writings, and his love of arcane texts such as Ignatius Donnelly's *Atlantis: The Antediluvian World* (1882), Jensen saw similarities in the architectural plans of Mayan and ancient Egyptian temples and enjoyed exploring the improbable idea that Atlantis was the missing link. Perhaps we can read the systematic order of the checkers as emerging from or receding into the illusionistic depth of the sea, a myth of creation or destruction.

Although Jensen's conceptually layered works were more widely exhibited in Europe, especially Switzerland, he nevertheless had a high profile in the United States with one-person shows at the Guggenheim Museum (1961 and 1985) and the *XIV International Bienal of São Paulo* (1977) where he represented the United States, an exhibition that the Albright-Knox Art Gallery reorganized as a traveling retrospective in 1978. Now, two decades after his death, with a major retrospective at the Dia Center for the Arts in New York (2001-2002), there is renewed enthusiasm for what Grace Glueck calls the "color-drenched puzzles" of Alfred Jensen.

—GREGORY WITTKOPP

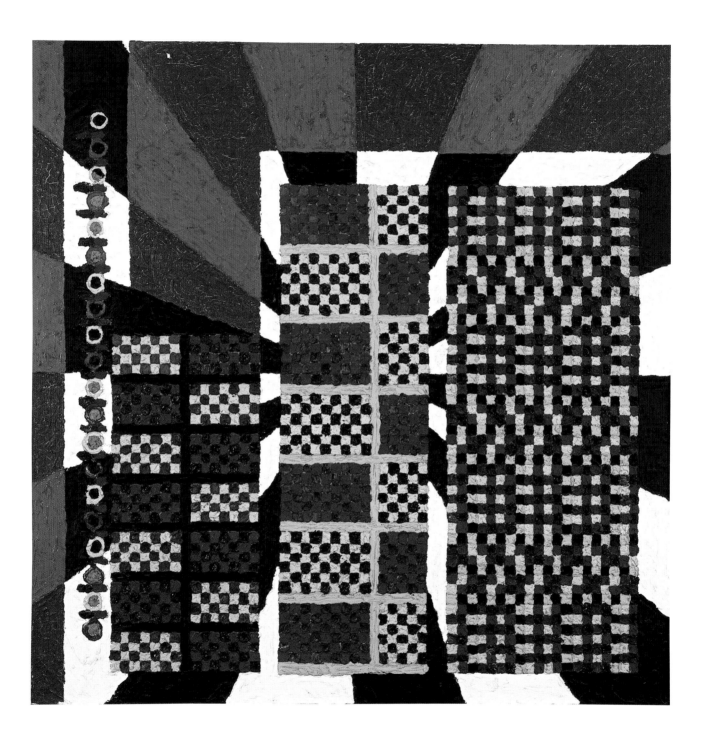

DONALD JUDD
(Born 1928, Excelsior Springs, Missouri; died 1994, New York, New York)
Untitled, 1972
Anodized aluminum
14 1/2 x 76 1/2 x 25 1/2 inches
(36.8 x 194.3 x 64.8 cm)

Acquired by Dr. John and Rose M. Shuey through Christie's, New York, New York, 1983

ADDITIONAL PROVENANCE
Ronald Greenberg Gallery, St. Louis, Missouri

EXHIBITION HISTORY
Donald Judd, Ronald Greenberg Gallery, St. Louis, Missouri, November–December 1972

CITATIONS
D. Del Balso, R. Smith and B. Smith, *Donald Judd-Catalogue Raisonné of Paintings, Objects and Wood Blocks 1960-1974* (Ottawa: National Gallery of Canada, 1975), p. 242 (illus.).

G. Muller, "Donald Judd – Ten Years," *Arts Magazine* (February 1973), p. 39 (illus.).

DONALD JUDD

Donald Judd, artist, critic and writer, gained attention in the 1960s for his industrially produced "objects." Judd abhorred the terms sculpture and Minimalism, though he often is referenced as the key originator of "minimalist sculpture." That his work, once decried as impersonal and sterile, is now considered by many to be the apogee of classical beauty, is testimony to the artist's singular aesthetic and essential understanding of color, order and form.

Judd graduated from the exclusive College of William and Mary in Williamsburg, Virginia, in 1948. That year, he moved to New York and, with the exception of a four-year stint in the military, Judd studied both art history and philosophy at Columbia University and the Art Students League until 1962. While pursuing graduate work in the late 1950s, he became an activist and started to paint and write critically about art. Judd wrote for *Art News* and became a contributing editor for *Arts Magazine*, a post he held until 1965. His stinging observations and blunt delivery—he hated anything autobiographical or anthropomorphic—earned him the enmity of many future colleagues.

Judd abandoned painting around 1961-62 when he decided that "actual space [was] intrinsically more profound and specific than paint on a canvas." Thus began a career producing what Judd famously termed "specific objects." These sleek, often box-like constructions were made of decidedly "non-art" materials, such as plywood, sheet metal, Plexiglas, cast steel and extruded aluminum. Stacked, aligned, cantilevered and centered, his strict geometric arrangements worked against traditional precepts of compositional beauty, enforcing instead a singular focus on the object itself and the space it occupied and activated. Distancing his work from Abstract Expressionism, the emotional, gestural style that dominated the 1940s and 1950s, Judd's objects were commercially fabricated using industrial processes and mechanical techniques. To further depersonalize his creations, Judd refused to give them proper names: they are all *Untitled*.

Judd based his work on precise and discrete systems such as mathematical progressions and geometric formulas, creating a visual language seemingly known only to the creator. In fact, Judd believed his vernacular was readily comprehensible to most viewers. He always employed three classical sequences: a Fibonacci series, in which each number is the sum of the preceding two numbers (1, 2, 3, 5, 8, 13, 21, 34, etc.); another sequence in which the volumes and spaces move inversely from left to right; and a series in which the volumes double in length in one direction while the spaces or voids in between double in the opposite. *Untitled* is an example of the last sequence. Also known as one of his "bull-nose" progressions, this same motif appeared in wide-ranging variations throughout Judd's career. The distinctive chartreuse color was achieved through the electrochemical process of anodization in which pigment is not applied to the surface but actually impregnated into the metal. Ever the purist, Judd viewed this as a more thorough way of integrating color into his work.

In 1991, three years before Judd's death, Yve-Alain Bois wrote that in Judd's work, "it is his solids . . . that assure us of the tangibility of his voids." If anything, this is one of Judd's greatest contributions: the ability to make the viewer see that negative space is as important as positive. An art of classical measure and balance able to evoke a depth and complexity of feeling perhaps not immediately apparent, Donald Judd's elegant "objects" defined a new form of expression in modern sculpture.

—JEFFREY D. GROVE

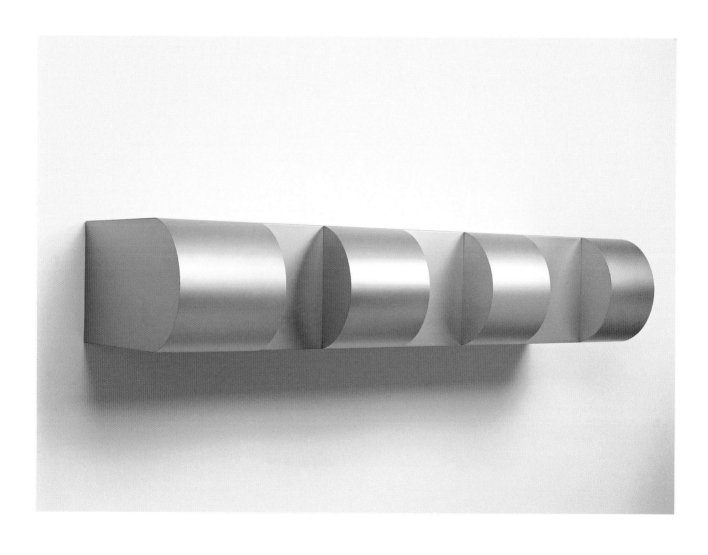

WILLIAM KING
(Born 1925, Jacksonville, Florida)
The Pair, not dated
Bronze
24 x 8 x 3 1/3 inches
(61 x 20.3 x 8.9 cm)

Acquired by Dr. John and Rose M. Shuey
through Christie's, New York, New York,
1984

ADDITIONAL PROVENANCE
Estate of Herbert Segerman
Terry Dintenfass Gallery, New York,
New York

WILLIAM KING

William King's *The Pair* captures our immediate attention through the expression of tender human interaction, which speaks to our memories and tempts us to project a narrative around what we see. King is recognized as a master in the use of body language, gesture, and clothing to reveal the personal dynamics of ordinary people in modern life. Harriet Senie aptly described his gift as "a deft grasp of the quick likeness and the ability to pick out the central gesture that reveals character and social situation."

Here a tall thin man, dressed in a 1960s-style short jacket with wide-lapels, flare-leg pants, stiff triangular-collared shirt, and thin tie, towers protectively over a shorter woman whose Twiggy-thin body presses through her mini-length shift dress. The height difference between the two figures might almost make her a child, but her stylish heeled boots, brilliantly suggested by the sculptor with minimal means, increase her age. She may still be the child of the man. Indeed the gentle placement of his left hand on her shoulder, with his other hand in his pocket, and the clasping of her arms behind her back, suggest something of parental concern. King often draws on personal experience in his work. Male figures usually echo his own lanky build, and interaction between large father and small daughter occur in at least two other works (*Learning*, 1969, and *Parent*, 1976). But here the female is older and the possibility of additional readings is open to the viewer.

Like Alberto Giacometti, King seems to capture his figures at a visual distance that the Swiss artist described as being just at the point where one recognizes an individual one knows. In King's case, the suggested specificity of clothing, facial features and posture suggest that each figure is a particular individual, yet the inventively spare detailing makes them into modern urban types.

King came to sculpture late. Born in Florida to a civil engineer father, he moved to New York and begin art training at Cooper Union Art School (1945-48) after two early years of academic study at the University of Florida (1942-44). A one-year Fulbright at the Academia de Belle Arti in Rome (1949-50) expanded both his knowledge of earlier art and his technical skills in working in lost wax to be cast in bronze. His mature personal vision engages more with the ironic than with the tragic side of life. His acute eye for depicting middle-class folks in action parallels that of Elie Nadelman, whose work King first admired in a 1948 exhibition at the Museum of Modern Art in New York. He also admired Picasso's witty ability to build figures from found objects. This found-object ability emerged especially in King's later work with found wood and twigs. But even in *The Pair*, we see his ability to use the texture and folds of plaster-soaked burlap to suggest varied materials and amazing details of clothing construction.

King has worked at every scale from miniature to monumental and in many materials, including Naugahyde, metal plates and wood. He is a prolific artist, who, like Picasso, feels little need to edit his output. Not every piece carries the expressive force of *The Pair*, which provides a moving glimpse into the poignancy of what Balzac and others have called "the human comedy."

—DIANE KIRKPATRICK

50

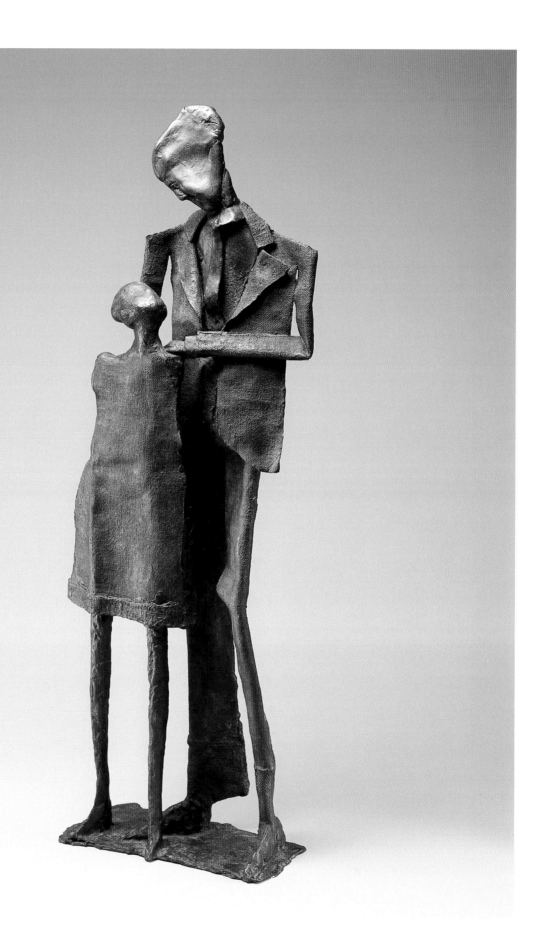

WILLEM DE KOONING
(Born 1904, Rotterdam, The Netherlands;
died 1997, East Hampton, New York)
Floating Figure, 1972
Edition 1 of 7
Bronze
24 x 14 x 14 inches
(61 x 35.6 x 35.6 cm)
Signed figure's right foot: "de Kooning 1/7";
figure's left foot: "Modern Art Fdry. N.Y."

Acquired by Dr. John and Rose M. Shuey
through Sidney Janis Gallery, New York,
New York, 1973

CITATIONS
de Kooning, Exh. cat. (New York:
Sidney Janis Gallery, 1972),
p. 13 (illus).

WILLEM DE KOONING

Dutch-born artist Willem de Kooning is best known, along with Arshile Gorky, Franz Kline and Jackson Pollock, as a first-generation New York School Abstract Expressionist painter. He attempted sculpture early in his career but abandoned it shortly thereafter, declaring that he didn't like the "feel" of clay. During a 1969 visit to Rome, however, de Kooning met up with an old friend, sculptor Herzl Emmanuel, who had recently acquired a small bronze-casting foundry outside of the city. Emmanuel invited de Kooning to visit him there, and the artist began to work again in sculpture, returning to the foundry many times that summer to make small figures in clay. Back in New York, the English sculptor Henry Moore, in town for an exhibition, saw de Kooning's sculptures, liked them, and suggested that they be enlarged. *Floating Figure* is one of an edition of seven from de Kooning's brief five-year period (1969-1974) of working in three dimensions.

Though cast in bronze and possessing a shiny patina, *Floating Figure*'s gouged, lumpy quality recalls its origins in the earthy brown clay used to shape its form. While in Rome, de Kooning often modeled his sculptures with his eyes closed, so as to "heighten their tactile quality"; he later shaped sculptures while wearing gloves to make the clay appear more coarse. In this work, traces of the artist's hands as he kneaded and twisted the malleable clay are clearly visible on the figure. Genderless and contorted, it seems to be still in the process of definition or of coalescing as a human form–a visual testament to de Kooning's statement that "Art never seems to make me peaceful or pure." With its attenuated arms, splayed fingers, and sinuous legs, *Floating Figure* seems suspended in a rapturous dance or, alternatively, in a state of haunting or shock. The figure's position evokes de Kooning's description of how he made a painting "with anxiousness and dedication to fright, maybe, or ecstasy." It also recalls Auguste Rodin's definition of sculpture as an art of "bump and hollow"; its protruding ripples and indentations produce a play of light and dark that heightens the emotional tension of the form.

Before moving to New York in 1926, de Kooning spent eight years in night school at the Rotterdam Academy of Fine Arts and Techniques, where he was trained in all media. The artist is renowned for his *Woman* paintings, a series marked by a combination of jagged, sketch-like lines and sensuous painterly curves, which he painted in the early 1950s and again in the 1960s. One of the few Abstract Expressionists to maintain figuration in his work, de Kooning's women, which are all versions of, in his words, "the idol, the Venus, the nude," are seductive and voluptuous, anguished and exiled at once. Their distorted figures convey what he termed a "raw, unbridled" feeling. His remarkable gift for imparting a sense of equilibrium between contradictory formal and evocative elements characterizes de Kooning's work in painting, drawing, and sculpture, and is evident in *Floating Figure*.

—LISA PASQUARIELLO

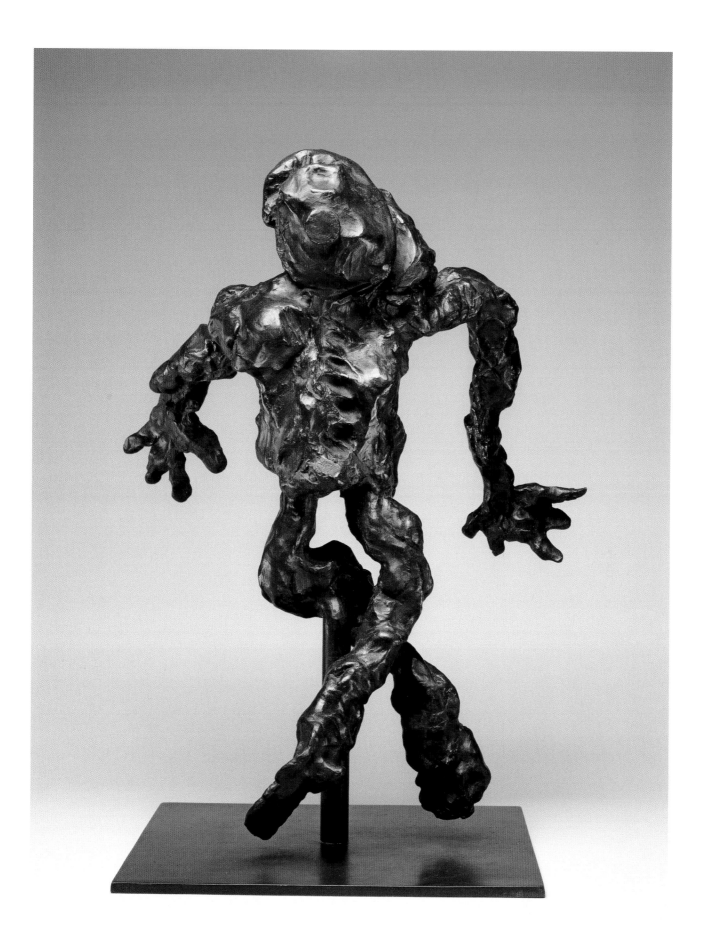

NICHOLAS KRUSHENICK
(Born 1929, New York, New York;
died 1999, New York, New York)
The Battle of Bull Run, 1963
Liquitex on canvas
84 1/2 x 53 1/2 inches
(214.6 x 135.9 cm)
Signed verso: "Nicholas Krushenick
June 1963"

Acquired by Dr. John and Rose M. Shuey
through Parke-Bernet Galleries, Inc.,
1970

ADDITIONAL PROVENANCE
Graham Galleries, New York, New York

CITATIONS
Donald Judd, "Nicholas Krushenick,"
Art International 38, no. 9 (May-June
1964), pp. 33-34 (illus.).

NICHOLAS KRUSHENICK

Nicholas Krushenick's *The Battle of Bull Run* blazons forth, presenting the viewer with a jaunty display in red, yellow, mauve, black, and white. The shapes are familiar, linked to the contemporary mass culture urban scene, yet impossible to absolutely identify. The title has no clear connection with the composition. The artist habitually lifted titles from suggestions by family and friends, or from the titles of the rock and roll music with which he filled his studio while working. Variously linked in the 1960s with Pop Art, Systemic Painting, and Hard Edge Abstraction, Krushenick's work sits uncomfortably within any one of these categories, existing in a dynamic world all its own.

The Battle of Bull Run, like the majority of Krushenick's work, has a sense of bilateral symmetry, energized by wavy shaped edges that impart a pulsating organic quality to the parts. The forms are large, crowding the canvas edges, suggesting that we stand close-up in the midst of this brilliantly hued world. The impact of the canvas owes much to the clean even application of flat color in areas separated by black lines. Krushenick's simple color patterns drew comparisons with Matisse's late *Jazz* collages, while black-lined shapes suggested links with Léger and 1960s Lichtenstein. Krushenick admired Matisse, but found his expression too European for direct influence, and noted that Léger and Lichtenstein were basically figurative artists, while he was an abstract painter.

Born in the East Bronx, Krushenick remembers being mesmerized as a boy with a mural that magically took shape between his weekly Sunday attendance at his neighborhood Greek Orthodox church. After a stint in the Army, he studied at New York City's Art Students League (1948-1950) and with Hans Hofmann (1950-1951). With his brother John, he founded and ran the co-op Brata Gallery from 1958-1962, showing among others, Ron Bladen, Al Held, and George Sugarman. Peter Halley cogently noted that these artists shared with Krushenick, "the desire to transform the physical energy of AbEx [Abstract Expressionism] into a vocabulary of coolly produced, impersonal, industrial and commercial-looking forms."

Krushenick was inspired by walking around Manhattan, noting patterns like "the way a fire escape is hanging or a neon sign . . . blinking someplace." These contributed to detailed colored drawings. When a drawing promised "a certain kind of dynamic element . . . a certain kind of mystery," Krushenick used it as the basis for a painting. Each painting proceeded intuitively, modifying the ideas in the drawings as the painting evolved when the colors and patterns did not work at the enlarged scale. Each work was "as different as possible," the opposite of making a systemic series.

Krushenick wanted his works to last. From 1959 onward, he used Liquitex paint because it not only gave him the kind of hard, clear colors he wanted, but was reported to last "roughly a thousand years." The artist was happiest when a composition emerged with no major changes as it progressed. Such a painting, he observed, had the "certain beautiful surface quality" for which he strove. If the emerging design lacked energy, he would "rip out" a section and replace it with thick even strokes to get the "power feeling . . . the wild kind of color power" he sought. A raking light reveals that *The Battle of Bull Run* once had some red "volutes" and radiating yellow bands in its upper half, now filled with a curving field of yellow, black, and white stripes.

The Battle of Bull Run dazzles and excites. Its power eludes verbal explication. As John Perrault wisely stated, "No cool description of Nicholas Krushenick's beautiful, energetic paintings will do them total justice. Analysis excludes joy."

—DIANE KIRKPATRICK

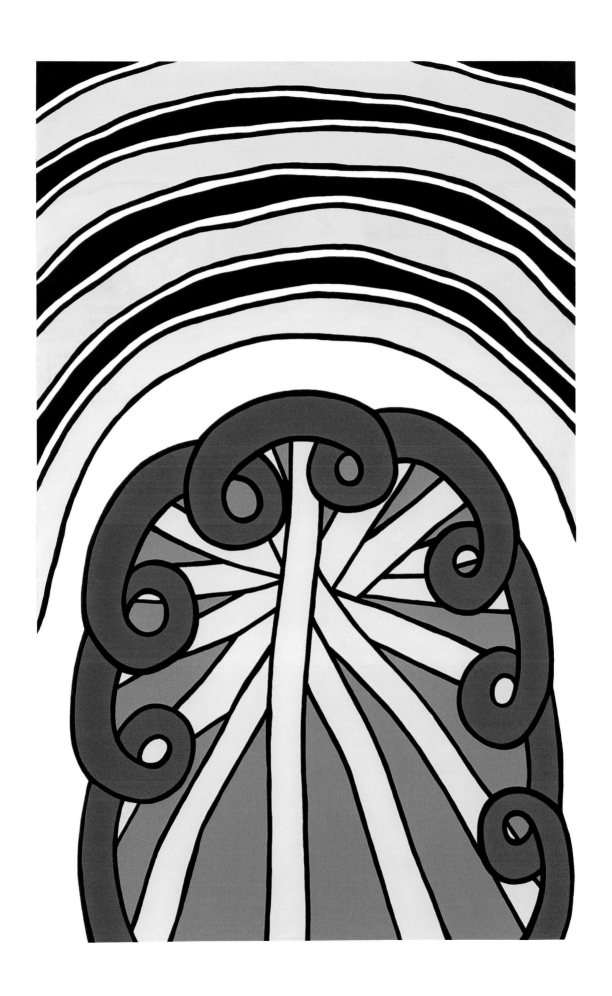

ROY LICHTENSTEIN
(Born 1923, New York, New York; died 1998,
New York, New York)
Modular Painting with Four Panels, No. 7
from the Modern Series, 1970
Oil and Magna on canvas
Four panels: 54 x 54 inches
(137.2 x 137.2 cm) each;
overall dimensions 108 x 108 inches
(274.3 x 274.3 cm)
Signed verso panel no. 1: "Roy Lichtenstein '70"

Acquired by Dr. John and Rose M. Shuey through
Leo Castelli Gallery, New York, New York, 1970

ROY LICHTENSTEIN

In the early 1960's, Roy Lichtenstein turned to the subject and style of comic books for his large-scale easel painting; this bold elevation of popular culture into so-called "high art" would place him among the legendary pioneers of American Pop art including Andy Warhol, James Rosenquist and Edward Ruscha. Lichtenstein appropriated advertisements for produce and household appliances, war and romance comics, and other commercial subjects, and then rendered such banal imagery in elegantly painted versions of the Benday printing process (a technique developed by Benjamin Day used to achieve shading and tones by varying the size and spacing of printed dots). Lichtenstein's emulation of an industrial printing technique and his choice of mass culture as subject responded to an urgent sense of the mass media's widespread influence. When Lichtenstein took high art as source material—subjecting abstract expressionist brushstrokes, Picasso still lifes, and the abstractions of Piet Mondrian to his signature comic book dotting—he truly underscored the power of capitalism to turn all things into consumable goods. *Modular Painting* is a strong example of this kind of work that parodies art history and its "gift shop" trajectory. The painting belongs to the Modern Series Lichtenstein began in 1966 that took Art Deco design as its source, but only as it appeared in reproductions: on posters, in coffee table books, and as chic dish towels. *Modular Painting* is a high art simulation, playing off a cheap reproduction, by the able hands of an artist immersed in the unprecedented explosion of mass media imagery in postwar America.

Lichtenstein grew up in Manhattan. Like many New York artists he attended the Art Students League where he studied with the well-known chronicler of city life, Reginald Marsh. Lichtenstein learned much from Marsh, and one can imagine that the commercial, popular street scenes for which Marsh was known paved the way for Lichtenstein's own representations of an American vernacular. Lichtenstein was drafted into World War II, and then returned to attend art school where he earned a Master's degree from Ohio State University. His earliest work took up American Western subjects in the manner of Remington, but Lichtenstein quickly turned to Abstract Expressionism, which by the 1950s was seen as the only legitimate painting style for serious young artists. Lichtenstein would ultimately abandon Abstract Expressionism for the radical Pop idiom, but he always maintained that his commitment to significant form and expressive line was a vestige of his abstract expressionist days.

Modular Painting is a striking work that relies on Art Deco's characteristic play of geometric forms, which Lichtenstein would have found throughout New York City's skyscrapers, theater marquees, and movie house interiors. It is divided into four parts with the same decorative structure repeated in each section. Lichtenstien stenciled his characteristic blue and red dot patterns balanced against solid yellow, black, white, and red hard-edged forms. Heavy black outlines anchor the various shapes to the frontal plane and hold the overall rhythm of the picture in dynamic stasis. *Modular Painting* recalls an important history of geometric abstract painting from Mondrian through Lichtenstein's contemporary, Frank Stella. Unlike Mondrian, however, Lichtenstein does not seek spiritual renewal through abstraction's harmony of parts, nor, like Stella, is he obsessed with the inherent properties of painting itself. *Modular Painting* cleverly marries the high seriousness of abstract painting to the playful and parodic antics of a Pop art style. It was the inevitable resolution for the romantic painter in a media-saturated age.

—LISA WAINWRIGHT

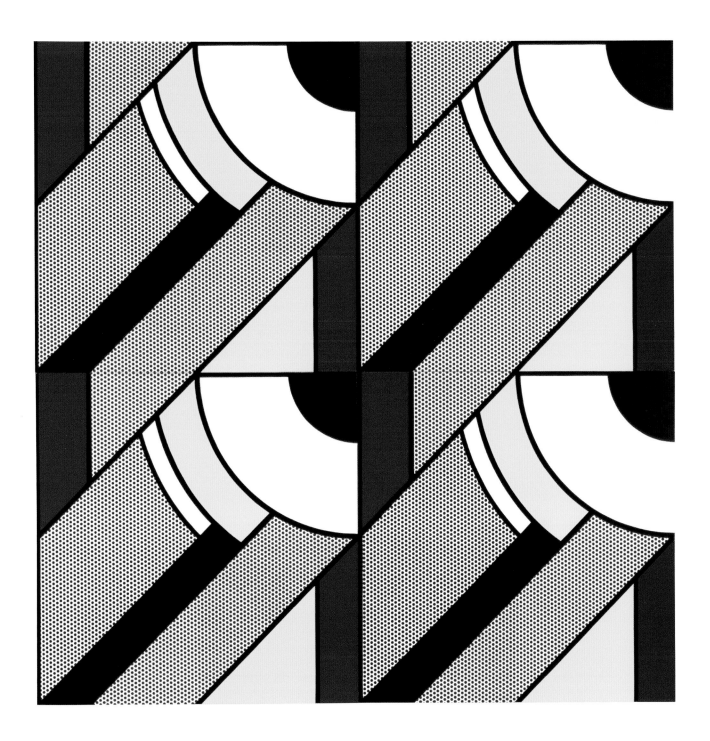

AGNES MARTIN
(Born 1912, Maklin, Saskatchewan, Canada)
Untitled, 1974
Acrylic, pencil and Shiva gesso on canvas
72 x 72 inches (182.9 x 182.9 cm)
Signed verso: "A. Martin 1974 #26"

Acquired by Dr. John and Rose M. Shuey through The Pace Gallery, New York, New York, 1976

EXHIBITION HISTORY
American Artists: A New Decade, Detroit Institute of Arts, Detroit, Michigan, July 30–September 19, 1976. Traveled to The Fort Worth Art Museum, Fort Worth, Texas, November 14, 1976– January 2, 1977.

Agnes Martin Paintings and Drawings 1957–1975, Hayward Gallery, London, England, March 2–April 24, 1977. Traveled to Stedelijk Museum, Amsterdam, The Netherlands, May 6–June 19, 1977.

CITATIONS
Agnes Martin Paintings and Drawings 1957-1975, Exh. Cat. (London: Arts Council of Great Britain, 1977), p. 45.

AGNES MARTIN

Understated yet commanding, ethereal yet tangible, Agnes Martin's restrained paintings have induced rhapsodic admirers to acclaim their spiritual nature and the transcendence they inspire. Whether because her subtle approach and private sensibility offer a tonic to our increasingly coarse, confessional culture, or because her paintings inspire "freedom from the cares of this world/from worldliness," Martin has achieved an extraordinary feat: she has captured nearly universal acceptance and praise for her work.

The perfection of Martin's work may appear effortless, but it was not easily achieved. Unlike many artists, Martin was well into her fifties before she first received true recognition. She had studied to become a schoolteacher at Western Washington College of Education in Bellingham (1934-37) and Teachers College at Columbia University in New York (1941-42 and 1951-52). In between, she studied art at the University of New Mexico and did not settle in New York to pursue art until 1957. But after her initial success in the early sixties, Martin abandoned art for nearly seven years. When she returned in the early seventies, it was with a resolve that has not wavered since.

Though she lectures, writes, and speaks freely of her work, the language Martin uses to describe it is, like the paintings themselves, universal, not personal. Indeed, she has strenuously avoided discussing her work in personal terms, as evinced by her statement, "My work is about emotion . . . not personal emotion, abstract emotion." That they are also "about" nature, while not describing nature and about humanity, if not the individual, also seems apparent.

While she is widely considered to be among the foremost abstract artists of the twentieth century, Martin's quiet paintings have none of the tumult often associated with "abstract" painting. Indeed, her paintings are peaceful and ordered. Always six-by-six feet, a size, she says, "you can step into," they are also less painted than inscribed. Canvases are impressed with gesso and acrylic and etched with India ink and graphite. Her calligraphic grids are—unlike the canvas—not really square, but rather rectangular, "in order to lighten the weight of the square, to destroy its power."

Although there is a preconceived plan for each painting (evidenced by the hand-written numbers often visible on the canvas), they have none of the mechanical or manufactured quality some associate with Minimal art. The mark of the artist is visible throughout. Line weights change with the pressure of her hand and blemishes from brushes, knives and tools are all apparent. Nonetheless, each canvas appears to meld magically into a seamless whole while revealing the process of its making. *Untitled* is no exception and typifies Martin's approach and characteristic use of materials. The canvas was prepared with a uniform white pigment; the alternating bands of pale orange and muted blue appear stained, the result of the thinner paint absorbing into the lighter ground. Each strip of color is clearly outlined with a graphite line.

Despite their shared vocabulary, slight variations in tone and scale from canvas to canvas nonetheless endow each painting with a "distinct climate and emotional tenor." Martin's own emotional climate is clearly one of peaceful acceptance and transcendent meditation. Taoist instruction has provided the strongest influence on Martin and her work, a philosophy that teaches natural simplicity and humility as a way to peace and harmony in life. In a 1976 lecture she observed, "The artist tries to live in a way that will make greater awareness of the sublimity of reality possible. Reality, the truth about life and the mystery of beauty are all the same and they are the first concern of everyone." To find an artist who believes this is perhaps not unusual. To find an artist who lives it is remarkable. Agnes Martin's sublime paintings testify that she does.

—JEFFREY D. GROVE

JOAN MITCHELL
(Born 1926, Chicago, Illinois;
died 1992, Paris, France)
Preface for Chris, 1973
Oil on canvas
Diptych, overall dimensions:
102 1/4 x 141 1/2 inches
(259.7 x 359.4 cm)

Acquired by Dr. John and Rose M. Shuey
through Sotheby's, New York, New York,
1982

ADDITIONAL PROVENANCE
Galerie Jean Fournier, Paris, France
Xavier Fourcade, Inc., New York,
New York

EXHIBITION HISTORY
Joan Mitchell, Whitney Museum of
American Art, New York, New York,
March 26–May 5, 1974

CITATIONS
Joan Mitchell, Exh. cat. (New York:
Whitney Museum of American Art,
1974), cat. no. 21.

JOAN MITCHELL

Gestural abstraction is the kind of painting that closely reveals the inner life of the artist. Like one's manner of speech or a particular gait, the sweep of the brush captures the idiosyncrasies of the hand that makes the mark. Joan Mitchell was one of the greatest practitioners of this style, transforming visions of nature—the Chicago lakefront, her Parisian garden—into a personal palimpsest of emotional responses. Mitchell made painting after painting brimming over with evolving and elapsing forms, making process visible as a metaphor for changeable existence. The large diptych *Preface for Chris* is a stunning example of Mitchell's ability to structure passages of dramatic gesture, cool buoyant forms, dark ominous blocks of paint, and large tranquil backdrops punctuated by tendrils of dripping paint into a coherent narrative of abstract characters. It is poetic humanism at its best.

Mitchell grew up steeped in poetry and art in a prosperous Chicago family. She attended Smith College, but, anxious to pursue her interest in painting, left after two years to study at the School of the Art Institute of Chicago. Like all aspiring artists of her generation, she was drawn to New York City and moved there to work in the context of the reigning Abstract Expressionists. The competitively macho climate, however, soon proved enervating and she eventually fled to France, which she had been visiting for years. There, amidst the great tradition of avant-garde art, Mitchell slowly built her own formidable reputation.

Mitchell took many cues from the moderns: Matisse's shocking planes of color, Kandinsky's rhythmic articulation of forms, and Cézanne's revolutionary conception of pictorial space collided in Mitchell's evolving style. Dubbed "Second Generation," or "Abstract Impressionist" due to the paintings' source in nature, Mitchell abhorred such categorization of what she considered an independent working method. Of course, the paintings did rely on some of abstract expressionism's gestural marking—this was the prevalent style of the day—but Mitchell avoided the Surrealist-Jungian excavation of the "primitive" unconscious that drove much of the early abstract expressionist work. Similarly, she was disinclined towards the existential tenor of the group, despite her close friendship later with the great existentialist Samuel Beckett. The idea of asserting "being" in the face of "nothingness" just didn't move her in the way that responding to her French Linden tree in the front courtyard did. Mitchell sought a pictorial language that mapped out where the outside world of nature met the inner spirit.

Joan Mitchell painted for forty years and had her first major retrospective in 1988 at the age of sixty-two. She struggled in an art world whose patriarchal bearings only saw fit to support the work of men. And she worked against the larger social system's division of labor that left women few choices outside of the home. But Mitchell was undeterred and in her paintings one follows the confident strokes of her defiance. Like Rosa Bonheur, Berthe Morisot, and Georgia O'Keefe before her, Mitchell took nature as her muse, then recreated her connection to it through the wondrous language of painting. *Preface for Chris* is one of the *coups de grâce* of Joan Mitchell's full career.

—LISA WAINWRIGHT

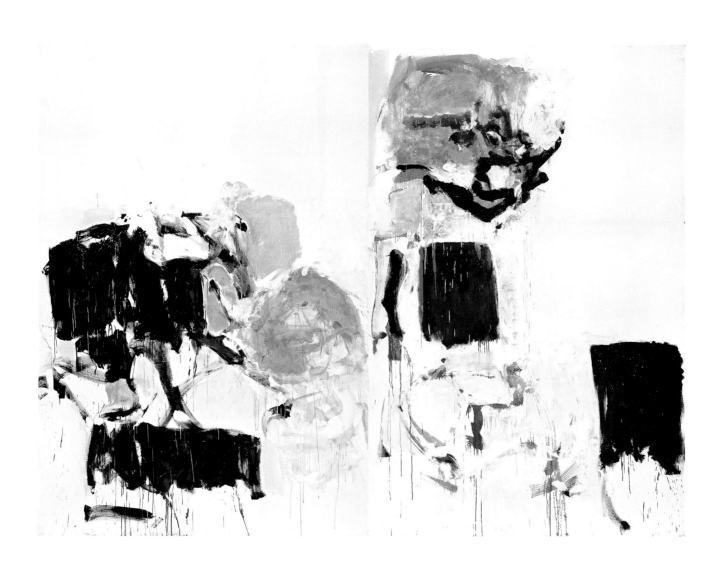

ROBERT MOTHERWELL
(Born 1915, Aberdeen, Washington;
died 1991, Provincetown,
Massachusetts)
Red Open #3, 1973
Acrylic on canvas
84 x 42 inches (213.4 x 106.7 cm)
Signed upper right: "RM 11 Jan 73"
Signed verso: "R. Motherwell 'Red
Open #3' 1973"

Acquired by Dr. John and Rose M. Shuey
through Sotheby Parke Bernet, Inc.,
New York, New York, 1979

ADDITIONAL PROVENANCE
M. Knoedler & Company, Inc.,
New York, New York
Dart Gallery, Chicago, Illinois

CITATIONS
Jonathan Fineberg, "Death and
Maternal Love," *Artforum* 17, no.1
(September 1978), p. 53 (illus).

ROBERT MOTHERWELL

The art of Robert Motherwell is distinguished by subjects both tragic and lyrical, a temperament alternately ascetic and sensual, and compositions by turns monumental or intimate. Motherwell studied philosophy at Stanford (B.A. 1937) and at Harvard University. Settling in New York in 1939, he continued his studies at Columbia University and became acquainted with Willem de Kooning, Adolph Gottlieb, Jackson Pollock, and Mark Rothko, all influential members of the first generation of Abstract Expressionist painters. His academic background and literary skills prompted him to organize forums, symposia, and panel discussions, as well as write and lecture to promulgate and clarify the principles of the new abstract painting being produced in the 1950s.

Red Open #3 is a signature work from Motherwell's Open series of paintings which he initiated in 1967. Painted a vibrant crimson red, it towers seven feet in height. Its rich red field is animated by a white-outlined "window," several incised, undulating "strings" or "threads," and a pale but discernible *Je t'aime* (I love you) handwritten across the surface at the work's center. The symmetrical placement of the white "window" is offset both by the double white verticals of its left side and the freehand drawing of its outline. This rectangular opening is countered by the eight faint but sensuously wavering elements that flow down the red field. The confidential declaration, "I love you," might be interpreted as a reiteration of the "openness" Motherwell sought to convey in this body of work.

Indeed, the Open paintings, proffering an entrée into "an airy, rising world," complement Motherwell's preceding series, the dark, brooding Elegies to the Spanish Republic begun in 1948-49. He also shares with Matisse a fascination with the inside/outside theme of the window. Motherwell's earliest works bear such titles as *Spanish Picture with Window* (1941) and *Spanish Prison Window* (1943-44). The structural clarity of the Open canvases may owe something as well to the spare Minimalist aesthetic of the 1960s, though their emphatically hand-wrought character discloses a divergent sensibility. Motherwell returned to the Elegies and Open series at different times throughout his career. They mark the two poles, elegiac and celebratory, of his oeuvre.

Common to both, however, was the artist's engagement with the socio-political forces of each decade, from the existential doubt and indecision of the post-World War II era to the optimistic, youth-driven social revolution of the 1960s. Within these "large simplifications," as the artist referred to them—the Elegies that embodied the fears of the 50s and the Open paintings that embraced the hopes of the 60s—Motherwell conceived an extraordinary range of compositions varying widely in mood and expression. The format of the works in the Open cycle, for instance, included both horizontal and vertical versions, the window motif inscribed in charcoal or paint, and its rectangle-within-a-rectangle configuration ranging to infinitely varying proportions. Backgrounds, sensuous in hue and brushwork, might be the ripe, voluptuous crimson of *Red Open #3* in the Shuey Collection or dusky grays, Mediterranean blues, or earthy ochres. They are muralistic declarations of the exhilaration of open-ended possibilities.

In contrast to the Elegies and the Open series, Motherwell was also a prolific generator of collages from the 1940s through the 1980s that reveal an intimate, even autobiographical mode of artmaking. Torn sheets of music that imply the sound and rhythm of music making and a variety of labels from wines, cigarettes and other comestibles that embody the everyday recur in these works. In *Black and White Striped*, the pyramidal composition suggests a classic still life arrangement anchored just right of center by the outline of a gray, tapered bottle form. This shape is emblazoned with a produce label and overlapped by a scrap of German sheet music and a torn fragment of one of the artist's gestural, calligraphic drawings. Intriguingly, the majority of forms are irregular in shape or painterly in texture in contrast to the geometry of the circular Spanish labels and the rectangular frame. These elements stabilize the disparate fragments as well as the opposing movements of the gray upright form at right and the downward tug of the artist's triangular remnant of calligraphy at lower left.

—DENNIS ALAN NAWROCKI

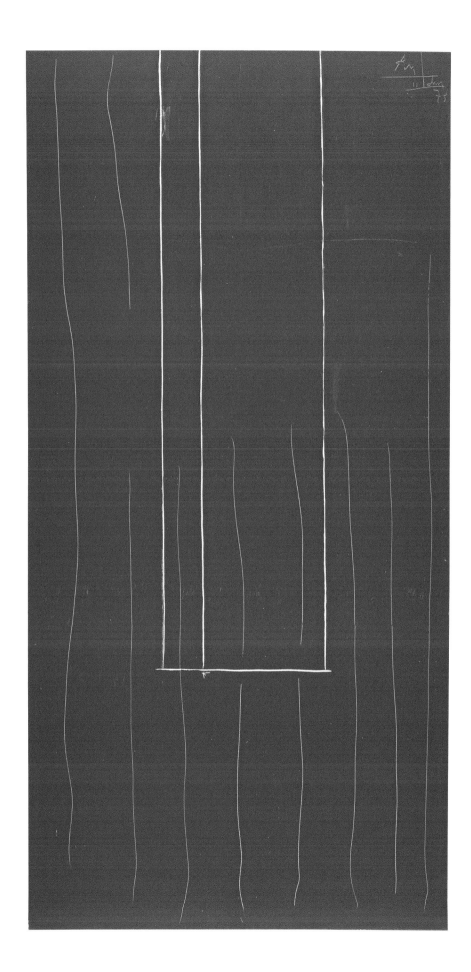

ROBERT MOTHERWELL
(Born 1915, Aberdeen, Washington; died
1991, Provincetown, Massachusetts)
Black and White Striped, 1984
Collage and acrylic on canvas panel
36 x 24 inches (91.4 x 61 cm)
Signed upper left: "RM 84"

Acquired by Dr. John and Rose M. Shuey
through M. Knoedler & Company, Inc.,
New York, New York, 1984

EXHIBITION HISTORY
Robert Motherwell: New Collages, M. Knoedler &
Company, Inc., New York, New York, October 3–
October 25, 1984

Robert Motherwell: The Collaged Image, Walker Art
Center, Minneapolis, Minnesota, September 28–
December 1, 1985. Traveled to Sioux City Art Center,
Sioux City, Iowa, January 18–March 2, 1986; Hood
Museum of Art, Hanover, New Hampshire, April
5–June 22, 1986; Fort Wayne Museum of Art,
Fort Wayne, Indiana, July 26–September 21, 1986;
and The Boston Athenaeum, Boston, Massachusetts,
January 5–March 1, 1987

CITATIONS
Robert Motherwell: New Collages, Exh. cat.
(New York: M. Knoedler & Company, Inc., 1984),
inside front cover (illus.), p. 7 (illus.).

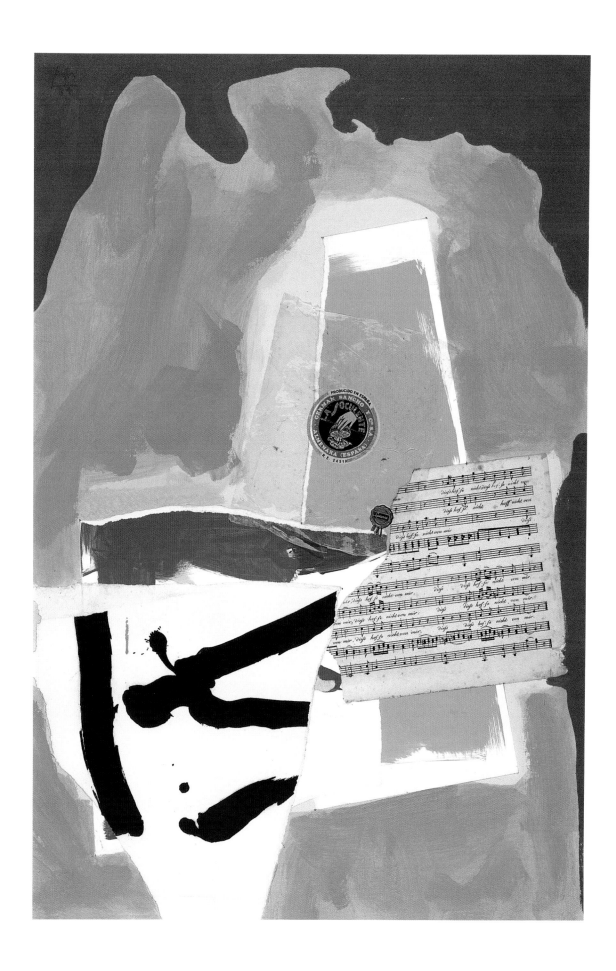

CATHERINE MURPHY
(Born 1946, Cambridge,
Massachusetts)
Nighttime Self-Portrait, 1985
Oil on canvas
16 3/4 x 16 1/8 inches (42.5 x 40.1 cm)
Verso: "C. Murphy © '85"

Acquired by Dr. John and Rose M. Shuey
through Sotheby's, New York, New York,
1996

ADDITIONAL PROVENANCE
Collection of Mrs. Robert M. Benjamin,
New York, New York
Xavier Fourcade Gallery, New York,
New York

EXHIBITION HISTORY
The Window in Twentieth-Century Art,
Neuberger Museum of Art, Purchase,
New York, September 21,
1986–January 18, 1987

CATHERINE MURPHY

Catherine Murphy's work has always expressed both her acute perceptions of her personal world and her sense of the geometries underlying its ordinary objects and places. *Nighttime Self-Portrait* shows the view seen by the artist looking through a nighttime upper window of her house at an outside porch entrance, which intersects with the dim reflection on the glass pane of her face, shoulders, and a bit of interior door and wall. The mullions of the interior window frame are rendered with such illusionistic care that they seem to protrude into our space. This transforms the window's surface into the picture plane. Catherine Murphy's reflection places her on "our" side of the picture plane, while through the window "in the picture" lies an assembly of cubic steps and building parts.

Born in Cambridge, Massachusetts, Murphy studied at Brooklyn's Pratt Institute (B.F.A. 1967), and spent the summer of 1966 working at Skowhegan School of Painting and Sculpture. Early on, Murphy was hailed as a contemporary Edward Hopper, and compared with artists like Jane Freilicher, Neil Welliver, and Fairfield Porter. As an admirer of the spare Minimalist work of Robert Ryman, Robert Mangold and Brice Marden, however, the tension between representation and abstraction is higher in Murphy's work. She says, "The point of doing figurative paintings is to achieve a balance between content and form . . . about finding the geometries in what looks like chaos." To Murphy, geometry is a natural part of human perception of the visible world, a view reinforced by a rectangle she found near a reindeer in a reproduction of Lascaux cave walls. "I realized," she commented, "that rectangles are in our heads, they're natural to us."

In an early exhibition, Murphy hung three works together as *Garden of Eden Trilogy*, a narrative constructed for the show "about the apple and how Eve, in eating it, gave us all self-consciousness. Without self-consciousness, there would be no art." In *Nighttime Self-Portrait*, the translucent veils through which we see into the rear room of the exterior structure recall an early comment by the artist about being "a watcher behind curtains." Here the painter observes an unpeopled part of her domain from a perch high in her home. Self-portrait details of clothing and physiognomy are rendered with a fine brush, but dulled to capture the mysterious quality of a nighttime reflection. Our attention is caught by the off-axis framings of the crisply-focused window mullions, which are echoed by the dim verticals of the door jamb behind her figure, and counterpointed by the showy illuminated cascade of shapes in the yard below.

Although at first glance, one might say Murphy's paintings are "photographic," she prefers to work directly from her chosen subject. The result is not a painstaking record of a scene frozen in time, as in a photograph. Rather, the artist says that her works "show what I was seeing changing in time." The viewer catches hints of this time-vision in incongruous details in *Nighttime Self-Portrait*, like the sudden jog in the upper frame of the window to the left of the lighted porch's entry door, or the mismatch between the top of the red door and the roofline of the attached "garage" below the lighted rooms. This is a magical world. Murphy's works are, as Linda Nochlin wrote in 1985, "charged with a very contemporary awareness of the ambiguities of the domestic, of the ways, both dramatic and subtle, that the known shades into the mysterious, the personal into the objective, the cozy into the uncanny."

—DIANE KIRKPATRICK

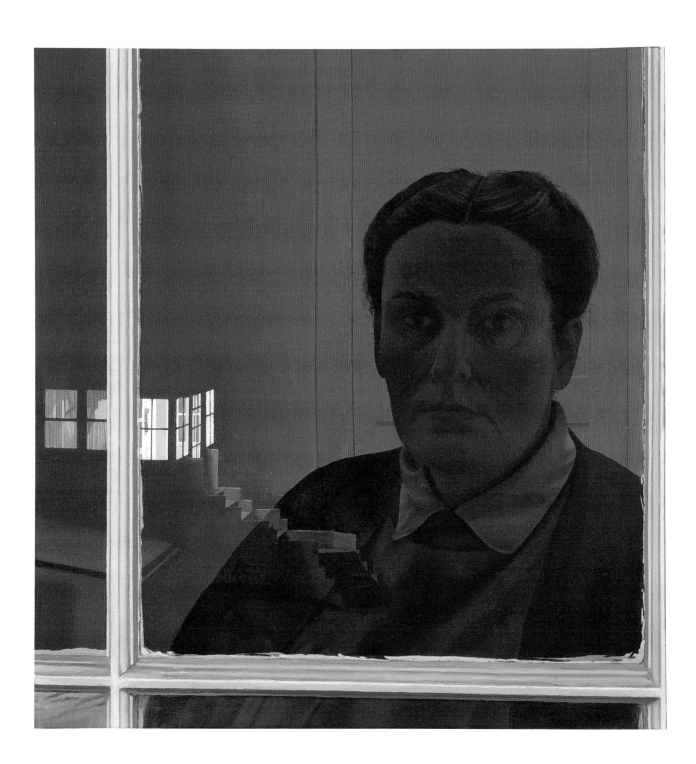

ELIZABETH MURRAY
(Born 1940, Chicago, Illinois)
Melting Clock, 1990
Pastel and string on paper
44 3/4 x 37 inches (112.4 x 94 cm)

Acquired by Dr. John and Rose M. Shuey
through Sotheby's, New York, New York,
1999

ADDITIONAL PROVENANCE
Paula Cooper Gallery, New York,
New York

ELIZABETH MURRAY

The large biomorphic shape in Elizabeth Murray's *Melting Clock* tantalizes the eye and mind as one passes through stages of deciphering its meaning. The lush color and tactile torn edges of the central pasted shape float forcefully against their paper field. At first sighting, the biomorphic form may suggest a simplified cartoon profile, reminding us of Murray's liking for what Kathy Halbreich called, "the simplification, the universality, the diagrammatic quality of the marks [of cartoon drawing], the breakdown of reality, its blatant, symbolic quality."

However, the surface of Murray's pastel painting is too dense and its details too mysterious to support a single reading of a cartoony "head." *Melting Clock's* title points to the common object, and we see clock hands whose arrow-ended gilded-string lines wriggle in three directions out from a central anchoring oval. An obvious precedent is the limp watches inhabiting Salvador Dali's *Persistence of Memory*. These, in turn, reference a multitude of writings on the elusiveness and malleability of time. Here, as always with Murray, the object-subject carries meanings beyond its visible form. The allusive meanings arising from Murray's deliquescent clock-object are in never-ceasing interplay and tension with the physicality of the painting's materials. *Melting Clock* is built with a densely layered pastel surface, in which individual strokes of color blend into a rich optical texture, and shapes swell sensuously through the sumptuous use of light and shadow modeling. Here we experience Murray's "requirement that the viewer have a sense of the drawing being made," as Clifford Ackley has observed.

Elizabeth Murray was born in Chicago, and used the collections of the Chicago Art Institute as a key resource during her pursuit of a B.F.A. at the Institute's School (1962). She widened her knowledge of modern art and technique at Mills College (M.F.A. 1964), before moving to New York City. Not surprisingly, past art that attracts Murray shares a dense physicality. About Cézanne she says, "I . . . just loved the physical quality of his painting. . . . [The] painting around the form was as intense as the painting of the form: in a sense, there was no figure/ground." She also notes a similar attraction to the "feeling for paint" in the works of Max Beckmann and Willem de Kooning.

Murray's empathy for the physicality of surface is especially forceful in her sensuous use of pastels. The color palette in *Melting Clock* is darker than that of her earlier work. Murray speaks of her affinity for the "emotional range" of Picasso's color which she finds "harsher, stronger, more abstract" than the "soft and local" color of Matisse. *Melting Clock's* organic shapes and deep reds, lavenders, and yellows can suggest details of human flesh. The layered mysteries of her work often include sexual allusions, cogently described by Susan Rogers-Lafferty as the "sensuality and overt sexiness that exist in the luscious layering of paint, the metaphoric shapes that slither across the picture plane." Murray is known for the mysterious way in which her paintings incorporate shapes derived from objects and details from her home environment, which transform to the edges of multi-legibility. Here we experience them as part of a mesmerizing abstract composition, which tantalizingly evokes emotions tied to memories. Like the memories evoked by Marcel Proust's *madeleine*, they open the doors of deep psychological experience and meaning.

The discoveries made in looking at *Melting Clock* seem never-ending. This is a central characteristic of Murray's work, where, in the words of Roberta Smith, "Everything is in flux, is undergoing a process of change and distortion that is visually strange and abstract, but also psychologically real, and we enter into the process too."

—DIANE KIRKPATRICK

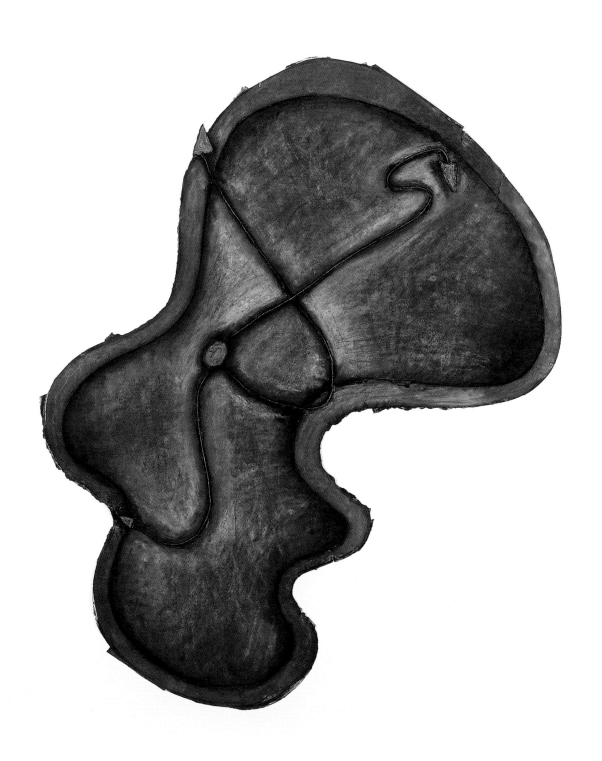

LOUISE NEVELSON
(Born 1899, Kiev, Russia; died 1988,
New York, New York)
Black Zag I, 1968
Wood and formica
47 1/2 x 47 1/2 x 5 inches
(120.7 x 120.7 x 12.7 cm)

Acquired by Dr. John and Rose M. Shuey
through The Pace Gallery, New York,
New York, 1968

LOUISE NEVELSON

Dubbing herself "The Architect of Shadow," Russian-born Louise Nevelson conceived and built the first of her monumental, wall-filling, black-hued wood sculptures by 1957. Often linked with other assemblage artists of the 1950s and 1960s, such as John Chamberlain, Mark di Suvero, Edward Kienholz, and Richard Stankiewicz, her choice of medium—found wood—initially distinguished her from her contemporaries. As she declared in her forthright memoir of 1976, *Dawns + Dusks*, "Now, no one, to my knowledge, at that time was using old wood. Sculptors were using the torch. . . . It was too mechanical for me. . . . I think the textures and the livingness . . . when I'm working with wood . . . [are] very alive."

Nevelson grew up in Maine, where her family emigrated in 1905, and where her father was both a builder and lumber dealer. After European study and travel in the 1920s, she settled in New York where she studied at the Art Students League and began the long process of discovering her sculptural language. By the mid to late 1950s she was constructing increasingly architectonic edifices composed of multiple box-like units stacked many levels tall. Each of the dozens of compartments was filled with cryptic juxtapositions of machined forms (balusters, spindles) and salvaged fragments (splintered planks, driftwood). Sprayed a uniform and evocative black, Nevelson considered it "the total color" and "the most aristocratic color of all."

In 1968-69, Nevelson originated a series of wall-mounted reliefs she called *Zags*. First exhibited in 1969, these eccentrically shaped pieces preoccupied the sculptor on and off over the next decade. *Black Zag I*, like many in the series, is composed of variously sized boxes aggregated in a zigzag, irregularly-stepped profile that may owe something to the currency of shaped canvases introduced in the 1960s. Like a number of others in the group, *Black Zag I* is enclosed in a wide, flat frame of black Formica.

Nevelson's composition is dominated by several shallow and densely packed boxes brimming with many small forms, some of which were designed and tooled to Nevelson's specifications or purchased commercially (children's building blocks and Lincoln Logs from Macy's, for example). In contrast, containers conspicuously spare and flat, two of which include half moon-like shapes, are placed at three of the four "corners" to mitigate the sculpture's overall density.

The sleek, seamless Formica frame, as smooth as the wooden circles, cylinders, spheres and cubes within the boxes, also tempers and contains the internal complexity of *Black Zag I*. Individual components appear in clusters, or in horizontal or vertical rows, producing an overall compositional unity that subordinates the individual elements. Metaphorically, idiosyncratic identity vanishes within a mysteriously shadowed whole that tellingly evokes the elemental yet problematic relationship of an individual to a totality.

—DENNIS ALAN NAWROCKI

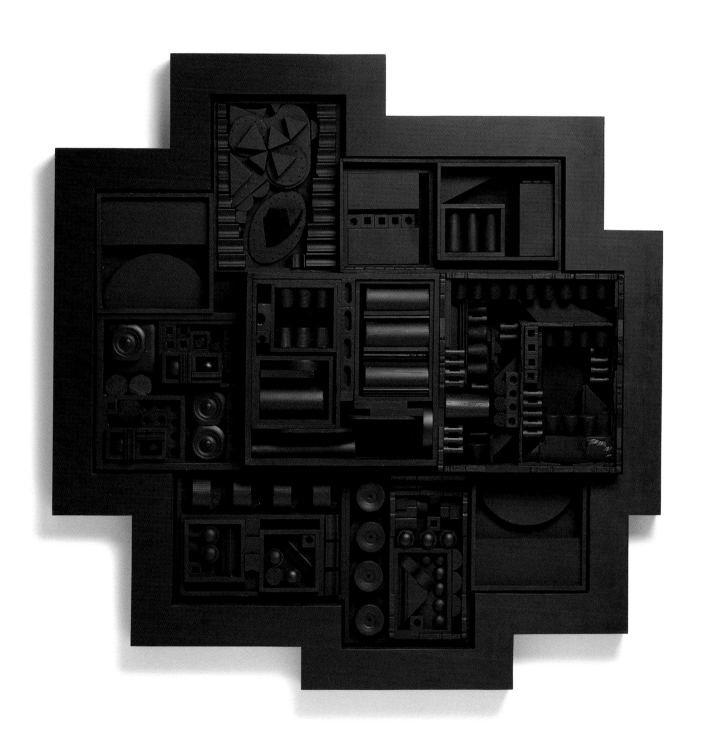

KENNETH NOLAND
(Born 1924, Asheville, North Carolina)
Burnt Beige, 1975
Acrylic on canvas
94 1/4 x 114 inches (239.4 x 289.6 cm)

Acquired by Dr. John and Rose M. Shuey
through Leo Castelli Gallery, New York,
New York, 1976

EXHIBITION HISTORY
New York Gallery Scene in Painting,
Joe and Emily Lowe Art Gallery,
Syracuse University, Syracuse, New
York, November 9–December 11, 1977.
Traveled to Munson-Williams-Proctor
Institute, Utica, New York, January 3–
29, 1978

CITATIONS
Milton W. Brown, Sam Hunter, John
Jacobus, Naomi Rosenblum and David
M. Sokol, *American Art*, (New York:
Harry N. Abrams, Inc., 1979), p. 562
(illus.).

Diane Waldman, *Kenneth Noland: A
Retrospective*, Exh. cat. (New York: The
Solomon R. Guggenheim Museum,
1977), p. 114 (illus.).

Kenworth Moffett, *Kenneth Noland*
(New York: Harry N. Abrams, Inc.,
1977), p. 223 (illus.).

KENNETH NOLAND

Over the course of the past four decades, Kenneth Noland has arrived at various solutions in his attempt to make work in which all elements of the picture, especially shape, serve as a vehicle for color. "I wanted to have color be the origin of painting. I was trying to neutralize the layout, the shape, the composition in order to get at the color," said Noland about the project of his artmaking. "I wanted to make color the generative force." At Black Mountain College in North Carolina, formal training in pure abstraction with Ilya Bolotowski and the Bauhaus master Josef Albers stressed the importance of attaining an equilibrium of color within a painting. A second formative experience in Noland's development was a 1953 trip from Washington, D.C., to New York City with his friend Morris Louis, the Color Field painter, to see the Abstract Expressionist artist Helen Frankenthaler. Frankenthaler poured paint onto raw (unprimed) canvas lying on the floor, thus allowing the pigment to soak directly into the cloth and resulting in pictures that emphasized the flatness of their two-dimensional nature. As Noland later recalled, Frankenthaler "showed us a way to think about, and use, color."

Noland adopted this stain technique for a series of concentric circle paintings begun in 1956, in which nested rings of vibrant, often uncomplementary colors occupied the center of a square canvas. A mix of hard-edged geometry and softer, thinly applied stains, the clash of color in these works generated a sense of outward pulsation. Continuing his exploration of the ways in which a picture's formal structure might be used to highlight color, the artist moved to painting ellipses, and then chevrons, in which the tip of an angled shape touched the bottom edge of the work. But soon Noland, then living and working in New York City, was frustrated by the "inertia" he sensed in the empty, raw corners of the canvas. In a trajectory emblematic of the idea of modern art as a self-critical process of solving successive formal problems, he painted a series of horizontal stripes and allover "plaid" patterns in the mid-1960s before beginning to vary the rectangular shape of the canvas by tilting it off-axis and using elongated diamond or irregularly shaped formats. More recent work from the 1980s features clay, handmade paper, and canvases of acrylic paint mounted on Plexiglas.

Burnt Beige is a "notched" painting; Noland has cut away the edges of a rectangle so that no trace of its original shape remains. Indeed, by titling his work after its predominant color, Noland directs our attention to his bold, unmodulated palette. Angular bands of black, bright blue and claret red, and a small white triangle, punctuate the ochre field. The colored forms are at diagonals to the edges of the canvas, but lack a regular structure or pattern; rather, we are meant to focus on the richness and relations of the work's constitutive colors. *Burnt Beige* elegantly illustrates something Noland said about this period of his work: "It took the experience of working with radical kinds of symmetry, not just a rectangle, but a diamond shape, as well as extreme extensions of shape, before I finally came to the idea of everything being unbalanced, nothing vertical, nothing horizontal, nothing parallel. I came to the fact that unbalancing has its own order. In a peculiar way, it can still end up feeling symmetrical."

—LISA PASQUARIELLO

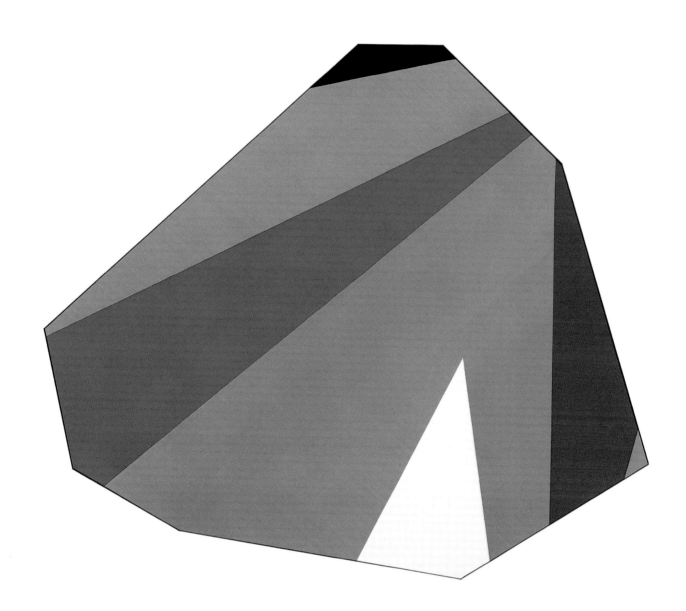

CLAES OLDENBURG
(Born 1929, Stockholm, Sweden)
Clothespin-Four Foot Version, 1974
Edition 1 of 9
Bronze and stainless steel on acrylic base
47 1/2 x 16 1/4 x 7 inches
(120.7 x 41.3 x 17.8 cm)
Signed on base: "Oldenberg 1979 1/9
Work executed by Lippincott North Haven CT"

Acquired by Dr. John and Rose M. Shuey
through Leo Castelli Gallery, New York,
New York, 1974

CLAES OLDENBURG

Claes Oldenburg is the most important sculptor associated with American Pop art. Although Pop art was diverse in expression, an attraction to the ordinary things of a consumer society bound together artists as different as Roy Lichtenstein, Robert Rauschenberg, James Rosenquist, Andy Warhol, and Oldenburg. Presenting the artifacts of popular culture in a straightforward manner, these artists were initially suspected of forfeiting any imaginative transformation of their sources. But Pop artists always altered the object at hand—be it a comic strip, a billboard, a media photograph or soup can. What emerged in their works were highly personal meditations instilled with ironic critiques of modern American culture. Since 1969, Oldenburg has produced over two dozen Large-Scale Projects, many of them in collaboration with Coosje van Bruggen. Located in cities of the United States and Europe, these "colossal monuments" include a flashlight, baseball bat, garden hose, binoculars, and shuttlecocks.

Oldenburg's "things" are not literal reproductions of familiar objects. With expansions in size, unexpected use of materials, and subtle simplifications of form, Oldenburg created things of the imagination, not of the five-and dime. The wonderment and wit of Oldenburg's art lies in the protean nature of the object's identity. It always appears to be much more than what it really is. Such is the case with Oldenburg's bronze *Clothespin-Four Foot Version*. Standing proudly on its rectangular base, it is closely related to the forty-five-foot-tall *Clothespin* in downtown Philadelphia that was inaugurated on the eve of the Bicentennial celebrations in 1976.

While flying over Chicago in 1967, Oldenburg held up a wooden clothespin to his window and matched it to the skyscrapers below. Upon returning to New York, he prepared a drawing of a skyscraper in the form of a clothespin for a commissioned cover of *Artforum*. Entitled *Late Submission to the Chicago Tribune Architectural Competition of 1922*, Oldenburg considered his scheme a fitting solution: "Perceiving in it a certain Gothic character, I visualized it as a substitute for the Chicago Tribune Tower on Michigan Avenue."

In 1972, the clothespin changed its geographical identity when it was used for a poster and an editioned screenprint designed in conjunction with the exhibition *Object into Monument* at the Philadelphia Museum of Art. When developers in Philadelphia commissioned Oldenburg in 1974 to create a Large-Scale Project, it was no surprise that they chose the clothespin.

On its way from Chicago to Philadelphia between 1967 and 1974, Oldenburg's clothespin was realized in a variety of media and scales. There are several finished drawings, a cardboard maquette with the sides of the clothespin open, and an original Cor-Ten steel maquette for the Philadelphia commission. The clothespin was also fabricated in two sets of editioned sculpture: a 6-ft. version in Cor-Ten steel for outdoor locations, and a 4-ft. version in bronze for indoor presentation. The first of the bronze editions entered the Shuey Collection in 1974.

Oldenburg saw the Philadelphia *Clothespin*, in its shape and "crack" down the middle, as a modern updating of the Liberty Bell. He further associated the clinging forms of the *Clothespin* with Constantin Brancusi's sculpture *The Kiss* in the city's museum, and with Philadelphia's identity as "The City of Brotherly Love." He even felt that the stainless steel spring, in a fitting nod to the American Bicentennial, resembled the numerals 7 and 6. Oldenburg always wanted his Large-Scale Projects to accommodate the history of their locations.

Through changes in material, scale, and context, an Oldenburg clothespin, like all of his objects, takes on multiple identities. The clothespin in the Shuey Collection is neither the architectural clothespin of Chicago nor the erotic/patriotic clothespin of Philadelphia. It is more human in scale, with legs astride and arms folded in the confident pose of a Greek sculpture fashioned in the "noble material" of bronze.

 —RICHARD H. AXSOM

JULES OLITSKI
(Born 1922, Snovsk, Russia)
Darkness Spread-9, 1973
Acrylic on canvas
85 x 33 inches (215.9 x 83.8 cm)
Signed verso: " to Clem, from—
Jules Olitski 1973"

Acquired by Dr. John and Rose M. Shuey
through Christie's, New York, New York,
1981

ADDITIONAL PROVENANCE
Private Collection

JULES OLITSKI

For Jules Olitski, one of the preeminent practitioners of 1960s Post-Painterly Abstraction, color, surface, scale, and experimentation with technique have been central to his art. Born in Russia, Olitski emigrated to New York with his family in 1923 where he later attended the National Academy of Design and the Beaux Arts Institute. After serving in World War II, he studied at the Académie de la Grande Chaumière, Paris, from 1949-50, and New York University from 1952-54. Initially influenced, like other artists of his generation, by the thick, impastoed surfaces of vanguard painting in the 1950s, Olitski and his Post-painterly contemporaries—Helen Frankenthaler, Morris Louis, and Kenneth Noland— soon began to stain or dye acrylic paint (just becoming widely available in the 1960s) directly into an unprimed canvas. The result, a smooth, textureless surface, glowed with luminous, high-keyed hues and broad swaths of color.

By 1964 Olitski had moved on to the execution of large spray paintings. Substantial in scale (some measured upwards of eighteen feet in width), these misty, hovering clouds of color sprayed onto the canvas bear such evocative titles as *Pink Drift*, *High A Yellow*, and *Lavender Liner*. To delimit the expansive nature of these vaporous mists, Olitski partially enclosed his compositions with thick, linear passages of paint, pastel, or crayon that paralleled one or more edges.

In 1972, desiring to move beyond the thin, intangible "skin" of his spray paintings, Olitski thickened his medium and applied the pigment with a roller or squeegee to develop variations in opacity and transparency. *Darkness Spread-9*, an early instance of this freshly-honed technique, embodies the artist's new interest in a tactile, wind-ruffled surface and muted, toned-down palette. The picture's import is indicated as well by the artist's handwritten inscription on the back of the canvas: "To Clem, from Jules Olitski 1973." "Clem" is Clement Greenberg, the influential critic of the 1960s and 1970s who encouraged, critiqued, and promoted not only Olitski's art, but also that of Anthony Caro, Helen Frankenthaler, Kenneth Noland, and Jackson Pollock.

The tall (almost seven feet in height), slim format (less than three feet in width) suggests *Darkness Spread-9* may be a mere fragment of a vast, cosmic process, namely the gradual dissemination of darkness evoked by the title. The "darkness," however, is of an overall wheat-colored hue, underneath and through which wisps of dusty rose and pale green are discernible. A gradually widening line of creamy pink impasto cuts across the top of the canvas. Its presence momentarily interrupts the diffusion of the painting's shifting field of color. As a pronounced element at the upper edge of the canvas, it counterpoints the "empty," largely monochromatic expanse of muted color.

As early as 1965, Olitski articulated what would become his life's work in paintings that both pre- and post-date *Darkness Spread-9*, namely an uninhibited exploration of the expressive potency of color: "Painting is made from inside out. I think of paintings as possessed by a structure—i.e. shape and size, support and edge—but a structure born of colour feeling. . . . I begin with colour. The development of a colour structure ultimately determines its expansion or compression—its outer edge."
 —DENNIS ALAN NAWROCKI

PHILIP PEARLSTEIN
(Born 1924, Pittsburgh, Pennsylvania)
Female Model Reclining on Red and Black American Bedspread, 1976
Watercolor on paper
29 1/2 x 41 inches (74.9 x 104.1 cm)
Signed lower left: "Pearlstein 76"

Acquired by Dr. John and Rose M. Shuey through Sotheby Parke Bernet, Inc., New York, New York, 1980

ADDITIONAL PROVENANCE
Private Collection, California
Allan Frumkin Gallery, New York, New York

EXHIBITION HISTORY
Philip Pearlstein: Watercolors and Drawings, Allan Frumkin Gallery, New York, New York, January-February 1977

CITATIONS
John Perreault with a foreword by Philip Pearlstein, *Philip Pearlstein: Drawings and Watercolors* (New York: Harry N. Abrams, Inc., 1988), p. 118 (illus.).

Jerome Viola, *The Painting and Teaching of Philip Pearlstein* (New York: Watson-Guptill Publications, 1982), p. 130 (illus.).

Philip Pearlstein: Watercolors and Drawings, Exh. cat. (New York: Allan Frumkin Gallery, 1977), color pl. 2 (illus.).

PHILIP PEARLSTEIN

Philip Pearlstein's unsparing depictions of graceless nude models in stark studio settings have long set him apart from mainstream aesthetic currents and *Female Model Reclining on Red and Black American Bedspread* is a perfect representative example. Indeed, for only a few years at the beginning of his career in the 1950s did his then-expressionist paintings of landscapes coalesce with the artistic temper of the times. By 1961-62 Pearlstein had begun his momentous shift to the representation of the human figure and simultaneous abandonment of gestural, abstract painting. Eschewing excess emotionality in favor of clarity and directness, he claimed to want "nothing of mythology, or psychology to obtrude; I wanted to divest my vision of both Freud and Jung."

Compositionally, however, Pearlstein was convinced that the realistic depiction of forms could rival the dynamics of abstract art. He explained, "The prime technical idea I took was that large forms deployed across the canvas produce axial movements that clash and define fields of energy forces, and that the realistic depiction of forms as they are in relation to one another in nature is as capable of creating these axial movements and fields of energy forces as are the forms of abstract art."

Such forceful movements are clearly in play in Pearlstein's large-scale watercolor in the Shuey Collection where the model's upraised leg seems to thrust into the viewer's space. Its pronounced movement to the right is countered by the outward bend of the model's arm at left and the inclined baseboard that darts across the "back" of the composition. The model's diagonal kick crosses the vertical established by the conjunction of her tucked-under leg and upraised arm at top center. All these crisscrossing axes are enclosed, moreover, within the fluid curves of the arms of the settee and the vibrating pattern of the red and black bedspread. For a medium often associated with soft, transparent effects, the forms in Pearlstein's watercolor are as hard and specific as both the deadpan title and the painting's dispassionate mood. As in most of Pearlstein's figurative works, the head of the model is abruptly cropped, denying the viewer a sense of individuality or personality.

"There must be no soft edges in the painting and no soft sentimentality either," Pearlstein asserted. Pearlstein's bluntness about his intentions is understandable, given the artistic ethos in which his art was maturing. The Abstract Expressionism of Franz Kline and Jackson Pollock remained influential and the emergent Post-Painterly Abstraction of Helen Frankenthaler and Frank Stella was highly touted. Hence, Pearlstein's shift to figuration struck many as too conservative for an artist well known in vanguard circles. Only in the late 1960s, with the advent of Photorealism— represented by, among others, Chuck Close and Richard Estes—did Pearlstein's point of view seem to be in synch with the zeitgeist. He, however, disassociated himself from the Photorealists by pointing out that he did not work from photographs. Indeed, a significant facet of Pearlstein's reeducation was his turn to one of the hoariest traditions of western art: the nude model posed in a studio illuminated by artificial light.

Though traditional in this respect, one would never mistake a Pearlstein composition for one by Titian or Courbet. His cropped extremities, unidealized postures, and cool demeanor embody a late twentieth-century outlook marked by psychic distance rather than emotional engagement. Not surprisingly then, furniture and fabrics often share equal attention (an American bedspread, here, for instance) with the figure.

Born in Pittsburgh, Pearlstein studied at the Carnegie Institute of Technology (now Carnegie-Mellon University) both before and after serving in World War II. Immediately after graduation in 1949 he moved to New York where he enrolled at the Institute of Fine Arts, New York University, completing his studies in 1955 and mounting his first one-person exhibition in the same year.

—DENNIS ALAN NAWROCKI

LARRY POONS
(Born 1937, Tokyo, Japan)
Wildcat Arrival, 1967
Acrylic on canvas
116 x 190 inches (294.6 x 482.6 cm)

Acquired by Dr. John and Rose M. Shuey
through Sotheby Parke Bernet, Inc.,
1978

ADDITIONAL PROVENANCE
Leo Castelli Gallery, New York, New York
Mr. and Mrs. Robert C. Scull, New York,
New York

EXHIBITION HISTORY
Larry Poons: Paintings 1963-1990,
Salander-O'Reilly Galleries, Inc., New
York, New York, April 3–30, 1990

Loan, Metropolitan Museum of Art, New
York, New York, June 1968-March 1969

*1967 Pittsburgh International
Exhibition of Contemporary Painting
and Sculpture*, Carnegie Institute,
Pittsburgh, Pennsylvania,
October 1967– January 1968

CITATIONS
Daniel Robbins, *Larry Poons: Paintings
1963-1990*, Exh. cat. (New York:
Salander-O'Reilly Galleries, Inc.,
1990), pp. 36, 37 (illus.).

*1967 Pittsburgh International
Exhibition of Contemporary Painting
and Sculpture*, Exh. cat. (Pittsburgh:
Carnegie Institute, 1968), cat no. 352.

LARRY POONS

The use of geometric patterns in bright, often contrasting colors, which produce a sense of visual stimulation and palpitation, was a hallmark of Op art painters in the 1960s, whose practitioners included Larry Poons and artists such as Richard Anuszkiewicz, Bridget Riley, and Victor Vasarely. In Poons' painting *Wildcat Arrival*, a loosely slanting grid of ochre, salmon, and lemon covers a larger-than-life canvas of gold; its small dots and ellipses seem to pulsate. One of Poons' early viewers told the artist that looking at his paintings often produced a sensation of after-images on the retina, and Poons tried to reproduce these effects in order to create the feeling of after-images *while* viewing. Poons worked in the lower-keyed, richly saturated hues used by painters he admired such as Morris Louis and Jules Olitski, thus combining the techniques of Op art with the palette of the movement that seemed its antithesis, Color Field painting.

Though evenly arranged in a geometric over-painted pattern, and composed of complementary hues, the dots alternate irregularly–some are circular, some elliptical–and no detectable pattern of color arrangement can be discerned. Poons had studied music at the New England Conservatory of Music from 1955-57 before turning to art, and was deeply influenced by the aleatory compositional procedures of John Cage. Cage's use of chance as a determining factor in composition and the desire to find order within randomness indeed seem to be organizing principles of *Wildcat Arrival*. And, like the "all-over" quality of work by abstract expressionists such as Jackson Pollock, this painting appears to extend beyond its edges, with some dots sliced off. As Poons said, "The edge defines, but does not confine, the painting."

Poons saw a Barnett Newman exhibition in 1959 and decided to become a painter, studying briefly at Boston's School of the Museum of Fine Arts. His first pictures featured configurations of small dots, evenly sized; he then moved to painting ellipses and eventually a combination of the two. These early works were painted on evenly stained grounds, but around the time of *Wildcat Arrival* the artist began to use more painterly, swirling washes of color under his elusively structured grids. Poons stressed the intuitive nature of his method: "The dot pictures were my best attempt to learn how to paint. I believe my coming up with the dots had something to do with what was in the air at that time: I had to keep it simple." His later introduction of ellipses was "an attempt to imply direction–left, right–rather than the static." In 1969, while Op art was still popular, Poons began working in a more tactile and spontaneous manner–pouring, dripping, and even throwing thick paint in muted colors onto his canvases. Though his working methods changed over the course of his career, the artist's oeuvre is marked by a persistent, compelling concern for the ways in which the formal structure of a painting can both harness and effect expression through the use of color.

—LISA PASQUARIELLO

ROBERT RAUSCHENBERG
(Born 1925, Port Arthur, Texas)
Moon Burn (Scale Series), 1977
Mixed media combine
84 3/4 x 144 1/2 x 40 inches
(215.3 x 367 x 103.6 cm)
Signed verso on vertical panels:
"Rauschenberg Moon Burn (Scale) '77"

Acquired by Dr. John and Rose M. Shuey
through Leo Castelli Gallery, New York,
New York, 1978

EXHIBITION HISTORY
Robert Rauschenberg, Leo Castelli
Gallery, New York, New York,
April 23–May 23, 1977

ROBERT RAUSCHENBERG

Robert Rauschenberg created some of the most ambitious art of the twentieth century using the bric-a-brac of his everyday world. With detritus collected from New York City streets—fabrics, tin cans, newspapers, bird wings, tires, magazine ads, pillows, electric fans, and twisted metal—Rauschenberg represented the emerging consumer culture of the 1950s while radically transforming the future of artmaking. Rauschenberg collapsed age-old hierarchies about subject matter and materials, putting high art reproductions next to comic book characters and juxtaposing abstract expressionist brushstrokes with mechanically printed signboard fragments. When in the early 1960s Rauschenberg began to concentrate on found imagery in silkscreen paintings and transfer drawings, he continued to let the look of the quotidian world assist in the visual effect of the piece. *Moon Burn* represents this well. It teems with found imagery and is a wonderful example of Rauschenberg's relentless exploration of new materials, structures, and technologies.

Rauschenberg was born in the rural refinery town of Port Arthur, Texas. After a stint in the Navy in California in the forties, he pursued formal study at the Kansas City Art Institute, the Academie Julian in Paris, and Black Mountain College with Josef Albers. Rauschenberg came of age artistically in a New York scene devoted to abstract expressionism; he was closely involved with de Kooning and others, but also migrated towards a new constellation of artists whose roots lay in the theories of Marcel Duchamp and in the practices of experimental composer John Cage. The artists in the Duchamp-Cage circle explored passages of the vernacular world—found sound for their music, discarded objects for their art, and prosaic movement for their dance. Unlike the reigning abstract expressionists who generated content from a psychic excavation of the interior self, these young artists abandoned what they viewed as egocentric control in favor of reorientations of found information.

Moon Burn is made up of four vertical wood panels, in which the array of found imagery occupies the bottom half of the composition while horizontal bands of colored fabric link the four panels across the top. Angling out from this two-dimensional medley is another support holding reflective material that picks up the blurred colors and forms of the opposite collage. Like Plato's "Allegory of the Cave," Rauschenberg shows us diminishing degrees of representation as we move away from the real. Four light bulbs dangle down from the top of the large structure illuminating the interior as if a work-site for some hieroglyphic excavation. Indeed, the images call for specialized readings and interpretations as their symbolism can only be understood in the context of the artist's entire oeuvre where these particular motifs recur. There are a number of newspaper pages displaying information from the New York Stock Exchange. These rows and columns of numbers create grids that reinforce the geometric order of the overall composition, and echo the long stretch of checkered cloth at the far right. Along with images of officious looking government buildings, they also refer to Rauschenberg's longstanding interest in symbols of commerce and politics. On the other hand, pictures of animals, including a mountain goat, which recalls Rauschenberg's well-known taxidermied Angora goat forced through a rubber-tire in *Monogram* of 1955-58, look to personal history by signaling his childhood with its menagerie of barnyard pets.

Moon Burn is like a mini-retrospective for it also includes a reproduction of a painting showing a reclining female nude, a high art staple in Rauschenberg's repertoire of signs. His common depiction of scantily clad male athletes as covert signs from a homosexual iconography, initiated during the repressive decade of the 1950s, appears here in a picture of a team of trapeze artists. Finally, Rauschenberg's optimism about technology finds reference in *Moon Burn*'s series of technical drawings. Even the title might refer to the United States space program, a subject he addressed in numerous silkscreens from the seventies. For almost fifty years, Rauschenberg has shown us what it looks and feels like to be living in modern America. His art is testimony to the role of the artist as social and historic commentator. *Moon Burn* is no exception.

—LISA WAINWRIGHT

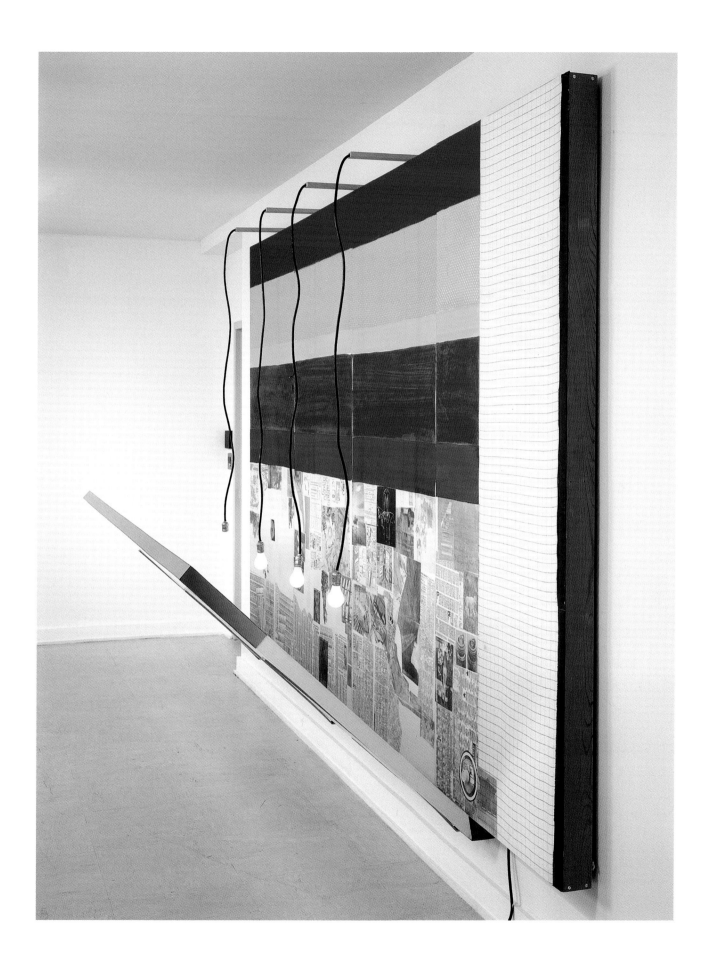

BRIDGET RILEY
(Born 1931, London, England)
Ch'i-Yün, 1974
Acrylic on linen
82 7/8 x 83 1/4 inches
(210.5 x 211.5 cm)

Acquired by Dr. John and Rose M. Shuey
through Sidney Janis Gallery, New York,
New York, 1975

EXHIBITION HISTORY
Bridget Riley, Sidney Janis Gallery,
New York, New York, April 30–May 31,
1975

CITATIONS
Bridget Riley, Exh. cat. (New York:
Sidney Janis Gallery, 1975), p. 3
(illus.).

Allen Ellenzweig, "Art Reviews," *Arts
Magazine* 50, no. 1 (September 1975),
p. 7.

BRIDGET RILEY

Bridget Riley's vibrant paintings, with their lively undulating surfaces, riveted international art world attention in the early 1960s. As bold graphic statements, their hallucinatory sensibility and tendency to induce optical unease in the viewer typified a new phenomenon, which came to be known as Op Art. Riley was considered its star practitioner, an honor that proved to be double-edged. When reproduced, Riley's high impact works conveyed little of the physical drama of viewing them in person and failed to communicate the complexity of the artist's painstaking technique. Once Madison Avenue trend shapers, fabric designers and window dressers seized on her style, Riley's works, and Op Art in general, came to be viewed as little more than a chic gimmick: illustrative icons of the psychedelic sixties.

Yet, while other so-called Op artists fell by the wayside, Riley persevered. Today, Riley's work serves as inspiration to an entirely new, eclectic generation of artists and her career has been favorably reevaluated by the critics. Her steadfast vision and aesthetic rigor may be an oddity, but Riley continues to mine visual excitement out of what some might view as radically reductive elements. Riley studied at Goldsmith's College of Art (1949-52) and the Royal College of Art (1952-55) before spending a formative year working for the J. Walter Thompson Advertising Agency, from 1958-59. In 1960, she first disclosed the distinctive approach that would become her trademark. Now, over forty years later, her mission remains unchanged: "My paintings are, of course, concerned with generating visual sensations, but certainly not to the exclusion of emotion. One of my aims is that these two responses shall be experienced as *one and the same*."

Both responses are indeed evoked by the two paintings in this collection, *Shih-Li* and *Ch'i-Yün*. With their cool palette and softly undulating surfaces, these works are clearly of the same family. Nearly twelve feet long, the massive expanse of *Shih-Li* increases the illusion that these wavy forms are rippling rhythmically like the sea. Colors ebb and flow like water itself as pacific tonalities interact. *Ch'i-Yün*, while possessed of no less an active surface, induces a different response. Contained as a perfect square, nearly seven-by-seven feet, its abbreviated length suggests waves traveling skyward, rather than along the horizon.

What Riley may be referring to in these paintings, with their Chinese titles, is a mood or feeling rather than a literal state. David Thompson notes that *Shih-Li* suggests qualities of momentum and force whereas *Ch'i-Yün* refers to a "breathing quality, an inner resonance and life." Each of these paintings illustrate how Riley—focusing intently only on subtle shifts in gradation and juxtapositions of color—is able to elicit complex and completely different sensations from the same essentially limited materials.

Such interactions and the responses they provoke are not accidental. Riley's paintings are the end product of an extensive preparatory phase in which every element of the painting is mapped and planned. She methodically develops the design schemes and composes the paintings by drawings and watercolors, including full-scale maquettes; she also organizes cutout colored shapes into variable patterns and further conducts extensive color tests. This data is finally transferred to prepared surfaces and completed by assistants.

Steady methodology and concentrated investigation have always been at the center of Riley's work. While stylistic progressions do occur, they reveal themselves slowly. Between 1974 and 1978, Riley worked exclusively on the "curve" paintings, a cycle from which these two canvases stem, in which the paintings were more lyrical and exhibited more clearly the personal dialogues Riley had always engaged in with painters dating back to the Old Masters.

Riley's paintings reveal the power of abstraction to suggest and elicit an infinite range of emotions and associations. Early in her career Riley likened her approach to sculpture. Just as the sculptor carves and thereby releases the figure from stone, Riley feels that she releases energy from her paintings via the relationship she establishes between elements. Through her purposeful technique and delicate articulations of mood and structure, Riley creates abstractions with a compelling visceral power. As the critic Robert Melville wrote in 1971, "No painter, dead or alive, has ever made us more aware of our eyes than Bridget Riley."

—JEFFREY D. GROVE

BRIDGET RILEY
(Born 1931, London, England)
Shih-Li, 1975
Acrylic on linen
63 x 140 inches (160 x 355.6 cm)

Acquired by Dr. John and Rose M. Shuey
through Sidney Janis Gallery, New York,
New York, 1975

EXHIBITION HISTORY
Bridget Riley, Sidney Janis Gallery,
New York, New York, April 30–May 31,
1975

CITATIONS
Allen Ellenzweig, "Art Reviews," *Arts
Magazine* 50, no. 1 (September 1975),
p. 7.

Roberta Smith, "Reviews," *Artforum*
14, no. 1 (September 1975), pp. 70
(illus.), 71.

Robert Hughes, " Making Waves,"
Time Magazine (May 12, 1975),
pp. 52, 54 (illus.).

Bridget Riley, Exh. cat. (New York:
Sidney Janis Gallery, 1975), p. 5 (illus.).

DOROTHEA ROCKBURNE
(Born 1921, Montreal, Quebec, Canada)
Arena III from the Arena Series, 1978
Vellum paper, colored pencil, varnish,
glue, and rag board
54 1/2 x 47 inches (138.4 x 119.4 cm)
Signed lower right: "Arena III
Rockburne 78"

Acquired by Dr. John and Rose M. Shuey
through Christie's, New York, New York,
1984

ADDITIONAL PROVENANCE
John Weber, New York, New York
HHK Foundation for Contemporary Art,
Inc., Milwaukee, Wisconsin

EXHIBITION HISTORY
Contemporary Art, Edwin A. Ulrich
Museum of Art, Wichita State
University, Wichita, Kansas,
May 7–August 31, 1980

*Dorothea Rockburne—Drawing:
Structure and Curve*, John Weber,
New York, New York, October 21–
November 22, 1978

CITATIONS
*Dorothea Rockburne—Drawing:
Structure and Curve*, Exh. cat. (New
York: John Weber, 1978), p. 18.

DOROTHEA ROCKBURNE

From cool austere works that employ large expanses of folded white paper to radiant and richly-colored compositions on flowing vellum sheets, Dorothea Rockburne's works are marked by intellectual rigor, innovation, and a remarkable sense of wonder. Although she has at times been associated with movements such as Minimalism, Process Art or Conceptual Art, her abstract works ultimately defy such classifications. Informed by a fascination with mathematics, science and astronomy and deeply influenced by the painting and architecture of the Italian quattrocentro, Rockburne's works embody a complex expression of correspondences.

Rockburne attended the experimental Black Mountain College in North Carolina in 1950 where she studied painting with artists such as Franz Kline and Philip Guston, music with John Cage, dance with Merce Cunningham and mathematics with Max Dehn. Alongside classmates like Robert Rauschenberg and Cy Twombly, Rockburne flourished at Black Mountain as she found the intellectual foundation and artistic inspiration for her future work. Following Black Mountain, Rockburne's early works were characterized by a reductive process and an economy of materials. Drawing lines and geometric shapes directly onto walls, cardboard or brown wrapping paper, Rockburne's works in the 1960s and early 1970s were subtle gestures that combined minimalist artmaking processes with her growing interest in geometry and mathematical theory. In these early works Rockburne explored the width, length and depth of the materials she used as she began folding her paper surfaces, often creating double-sided drawings. From this early period, Rockburne conceived her works in series as she explored the dynamic potential and various geometries of her otherwise flat and passive materials.

The Shuey Collection includes three of Rockburne's folded paper works from two significant series. The earliest is *Arena III* from a series named after the Arena Chapel in Padua, Italy, which contains Giotto's great fresco cycle. In the Arena Series, as in many of Rockburne's works, she employs the ancient mathematical device known as the Golden Section, which is a method of dividing a line in such a way that the shorter of the two sections stands in relationship to the longer section as the longer section stands to the sum of both. The proportions of the Golden Section were known and employed extensively by the architects of ancient Greece as well as by Italian painters and architects of the late Middle Ages and Early Renaissance. The proportional relationship of this geometric phenomenon appealed to Rockburne not only for its link to the history of Western art but because of its structure, which she characterized as "pure magic and light." The mystical geometry of the Golden Section drove Rockburne's artistic production from the time she first employed it in the mid-1970s.

Rockburne's *Arena III* features vellum sheets that have been marked by colored lines and arcs; when folded with Rockburne's precision, they create a pattern of overlaying crosses, triangles and other geometric forms. The translucence of the vellum makes every mark visible to some degree, while a layer of varnish on one side of the vellum differentiates the paper's front and back. A series of thin colored plumb lines indicates Rockburne's initial measurements while thick colored-pencil arcs articulate the many layers of Rockburne's foldings and overlappings.

Shortly after the Arena Series, Rockburne embarked on an extensive study of angels in religion and art history and began a series of related works. *White Angel #1* and *Guardian Angel 1* are two distinct works from this period. The quiet and elegant *White Angel #1* features stark white paper folded into a series of triangles. Blue plumb lines on the paper again expose Rockburne's calculations, revealing the significant role of process in her works. In contrast, *Guardian Angel 1* is distinguished by the sumptuous glow of purples, yellows and oranges laid down in luxurious layers of watercolor on vellum, creating a rich sense of depth and texture. Rockburne's first use of watercolor on vellum, the works in this series suggest a celestial source as their overlapping surfaces recall the atmospheres of distant planets. All three stunning works not only reveal the evolution of Rockburne's aesthetic explorations, but also underscore her passionate curiosity about the universe and its mysteries.

—IRENE HOFMANN

DOROTHEA ROCKBURNE
(Born 1921, Montreal, Quebec, Canada)
Guardian Angel 1, 1982
Watercolor on vellum
75 x 57 inches (190.5 x 144.8 cm)
Signed lower left: "Guardian Angel 1"
Signed lower right: "Rockburne 82"

Acquired by Dr. John and Rose M. Shuey
through Xavier Fourcade, Inc., New York,
New York, 1983

EXHIBITION HISTORY
*Dorothea Rockburne: The Way of
Angels 1981-1982*, Xavier Fourcade,
Inc., New York, New York, October 22–
November 27, 1982

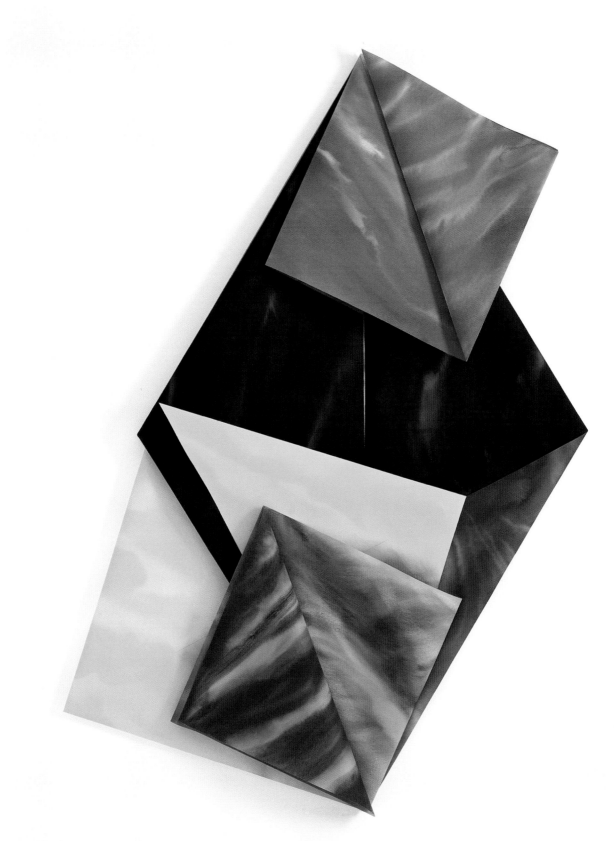

DOROTHEA ROCKBURNE
(Born 1921, Montreal, Quebec, Canada)
White Angel #1, 1981
Folded paper and blue pencil
70 x 46 inches (177.8 x 116.8 cm)
Signed lower left: "White Angel #1"
Signed lower right: "Rockburne 81"

Acquired by Dr. John and Rose M. Shuey
through Sotheby's, New York, New York,
1990

ADDITIONAL PROVENANCE
Xavier Fourcade, Inc., New York,
New York

EXHIBITION HISTORY
*Dorothea Rockburne: Egyptian
Paintings and White Angels*, Xavier
Fourcade, Inc., New York, New York,
September 22–October 24, 1981

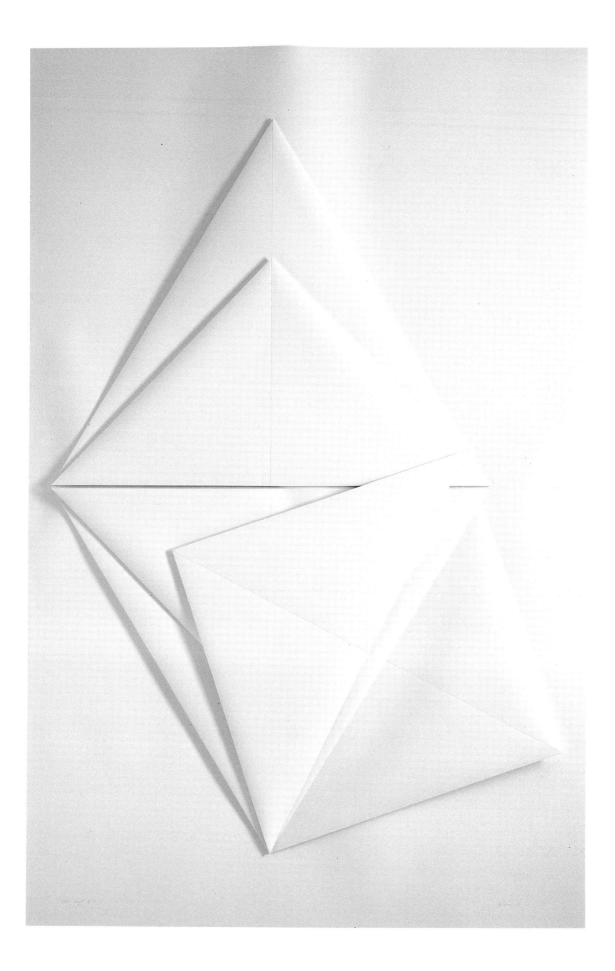

ZOLTAN SEPESHY
(Born 1898, Kassa, Hungary;
died 1974, Birmingham, Michigan)
Rock Garden, ca. 1955
Tempera on board
35 x 48 inches (88.9 x 121.9 cm)
Signed lower left: "Z. Sepeshy"

Acquired by Dr. John and Rose M. Shuey
through Frank Boos Gallery, Bloomfield
Hills, Michigan, 1989

ADDITIONAL PROVENANCE
Collection of Dorothy Sepeshy,
Birmingham, Michigan

EXHIBITION HISTORY
Sepeshy: Exhibition of Paintings,
Midtown Galleries, New York, New York,
December 26, 1956–January 19, 1957

CITATIONS
Sepeshy: Exhibition of Paintings,
Exh. brochure (New York: Midtown
Galleries, 1956), checklist no. 11.

ZOLTAN SEPESHY

Zoltan Sepeshy believed that artists had an important place in society: "Art is a vital and growing experience. It heightens, revitalizes, and makes secure the accidental perceptions and enjoyments that men find even in their ordinary activities . . . This is the world that not all men can see. This is the realm that one must open to others." Sepeshy's personal vision was honed through classical training at the gymnasium in his birth town of Kassa, Hungary (now Kosice, Czech Republic), and through work for a Masters degree at the National Academy of Art and the Academy of Art Teachers in Budapest. He pursued further studies in Vienna and Paris, and traveled in Germany, Italy and France, before he arrived in the United States in 1921 at the age of twenty-three. Appointed Resident Artist at Cranbrook Academy of Art in 1932, Sepeshy combined a successful professional career with teaching and administrative service (Director of the Academy from 1947-1959 and its President from 1959 to 1966).

Sepeshy painted the world around him, transforming industrial scenes, landscapes, cityscapes, and scenes of mundane human activity into compositions. He completed much large-scale work with murals on themes of transportation (1920s) and Michigan history (1930s and 1940s). But most often, he worked at "easel-scale" in the medium he seemed to love best, egg tempera painting.

Sepeshy's *Rock Garden* shares the luminous color and meticulously constructed surface for which the artist was known. But this painting is also a rare instance where Sepeshy's inspiration seems equally based on outer and inner vision. Before us rises a collection of boulders, blossoms, and triangular leaf-tree shapes that stretch almost vertically to a thin strip of dark blue "sky" at the top. This differs from traditional domestic rock gardens, shaped by human design. Here the setting is rougher, more mysterious. Details are elusive. Vibrantly colored blossoms float stemless across the center top of the picture. Rocks bulk forward with no suggestion of a central light source or coherent earth structure. The angle of view suggests that we look across this segment of nature from a position lying on the ground, where small things loom large, and we can marvel at things that would pass unattended from a standing pose. The colors have a particular intensity, which magnifies the sense of inner vision, of seeing beyond what is usually the surface of the world.

These effects spring from Sepeshy's meticulous tempera painting process, which was inherently meditative. Based on a preparatory full-scale master drawing, *Rock Garden* is painted on a Masonite panel, prepared with glue sizing, and eleven coats of white primer, with the image built by applying thin layers of color with a variety of flat- and round-shaped brushes (mostly sable, though long-bristled hog's hair oil brushes might be used in underpainting, and a toothbrush might be used in areas where the artist wanted a group of same-width evenly-spaced lines). Generally, Sepeshy relied on the white of his primed ground to provide an inner glow to his works, using no additional white pigment. In *Rock Garden*, several patches of light gray add to the rich visual counterpoint of vivid light and dark greens, blues, reds, oranges, and browns, which keeps the viewer's eye moving around the surface. *Rock Garden*'s viewers can revel in the magical ways with which Sepeshy's brush and paint re-present this scene as an assembly of shapes and colors, and participate in the artist's "heightening and revitalizing" of this rocky place. This eerily evocative work provides a rare glimpse into the rarely shared inner vision of a gifted humanist painter-educator.

—DIANE KIRKPATRICK

SAUL STEINBERG
(Born 1914, Râmnicul-Sarat, Romania;
died 1999, New York, New York)
Speech 2, 1969
Ink, watercolor, pastel, collage
29 1/4 x 39 1/4 inches
(74.5 x 99.7 cm)
Signed lower left: "Steinberg 1969"

Acquired by Dr. John and Rose M. Shuey
through Sidney Janis Gallery, New York,
New York, 1969

EXHIBITION HISTORY
Drawings by Saul Steinberg, Sidney
Janis Gallery, New York, New York,
November 5–29, 1969

CITATIONS
Drawings by Saul Steinberg, Exh. cat.
(New York: Sidney Janis Galley, 1969),
plate no. 73 (illus.).

SAUL STEINBERG

Speech 2, like many of Saul Steinberg's works, tantalizes viewers by seeming at first a light-hearted picture puzzle filled with visual puns. Quickly one is drawn ever deeper into wrestling with layers of meaning. Steinberg has been called "a writer of pictures" and "a draftsman of philosophical reflections."

Born near Bucharest, Romania, Steinberg studied sociology and psychology at the University of Bucharest before earning a doctoral degree in architecture at the Reggio Politechnico in Milan, Italy (1940). For him, "The study of architecture is a marvelous training for anything but architecture. The frightening thought that what you draw may become a building makes for reasoned lines." He published his first "cartoons" during these years in humor magazines and observed that, "In Fascist Italy, where the controlled press was predictable and extremely boring . . . the nature of humor itself, seemed subversive." The rising tensions of World War II forced him to undertake a roundabout journey out of Italy, which brought him to the United States in 1942. En route, his first drawings were published in the *New Yorker* magazine, which sponsored his entry into the USA.

From the beginning, Steinberg's subject was the wacky disparity between the world and the way each of us sees it. Mark Stevens reported in 1978, "Steinberg thinks of himself as a writer . . . [H]e speaks five languages fluently, but none perfectly. To write, he must therefore draw, and he likes his pictures to be carefully read." Steinberg "wrote" with lines, saying, "The doodle is the brooding of the hand." In *Speech 2*, lines define details of physiognomy, dress, speech, and indecipherable "official" calligraphy.

Speech 2 presents what could be the omnipresent modern media scene: a "talking head" (of indefinite gender) declaiming officially in some public place. The style is mixed. The hair is a brushy, soft black mass. The chin is limned with a sensitive delicate stroke. The lines of speech are diagrammatic areas of parallel lines, overlapping and angling against each other within the "talk balloon." Other features are created with stamped lines and emblems. One senses links to some of the multiple visual sources which Steinberg acknowledged: "Egyptian paintings, latrine drawings, primitive and insane art, Seurat, children's drawings, embroidery, Paul Klee."

Roland Barthes noted how every "thing" in a Steinberg work represents a representation. In *Speech 2*, the artist has played lavishly with "signs." Here, two stamped rectangles, set at a 45-degree angle to one another, become a mouth. A dental chart speaks of teeth inside the oral cavity, a single official record that signifies an individual's reality in the ordered social world. Here the outer skin of the personage merges with and emerges from the official notations of his/her existence, while the thin washes of red and blue across the upper and lower borders suggest a patriotic flag or badge.

Steinberg was fascinated by the ways in which each of us gains official reality only through our presence in official documentation—passports, identity cards, tax reports, licenses. Fake rubber stamps had served the artist well in successfully "reactivating" an expired passport to help in his escape from Mussolini's Italy, an experience that continued to inspire him. And bogus rubber stamps validate key areas of *Speech 2*'s space and personage, suggesting that the entire work represents a special kind of identity document.

We smile as we unravel the layered representations of *Speech 2* at the same time as we shiver at the darker implications of such a "reality." Here, Steinberg the writer of pictures joins a host of literary authors who saw the world through ironic pens, including Kafka, Molière, Pirandello, Beckett, and Ionesco.

—DIANE KIRKPATRICK

FRANK STELLA
(Born 1936, Malden, Massachusetts)
Takht-i-Sulayman Variation I from the
Protractor Series, 1969
Acrylic and fluorescent acrylic
on canvas
120 x 240 inches (304.8 x 609.6 cm)

Acquired by Dr. John and Rose M. Shuey
through Leo Castelli Gallery, New York,
New York, 1971

EXHIBITION HISTORY
Frank Stella, Leo Castelli Gallery,
New York, New York, November
18–December 6, 1969

CITATIONS
Jean-Claude Lebensztejn, "Eight
Statements," *Art in America* (July-
August 1975), p. 75 (illus.).

Frank Stella, Exh. announcement and
poster (New York: Leo Castelli Gallery,
1969), cover (illus.).

FRANK STELLA

Frank Stella has received great acclaim for his major contributions to abstraction, the most radical development in the history of twentieth-century modernism. Since the early 1960s, he has essentially rewritten the rules that constitute the format, materials, and meaning of abstraction. He accomplished this not only in the context of painting, but also in the realm of the print. Stella ranks with Pablo Picasso and Jasper Johns as the most prolific and innovative of modernist printmakers. Like Picasso, Stella's art has been one of continuous transformation, from the pristine geometries of his early paintings to the flamboyantly Baroque forms of the later work. The painting *Takht-i-Sulayman Variation I*, the collage relief-painting *Warka II*, and the mixed-media print *Fanattia* in the Shuey Collection are notable as a group for how well they represent Stella's overall development. Marking important milestones and displaying essential characteristics of Stella's art, they are an exceptionally fine introduction to it.

Takht-i-Sulayman Variation I is a monumental summary of Stella's abstraction as it had unfolded during the 1960s. Variously referred to as Hard-Edge Painting, Minimalism, and Post-Painterly Abstraction, its stylistic character stood in sharp contrast to Abstract Expressionism, which had dominated postwar American art. In its most important manifestation, the forms of the new abstraction were immaculate, flat, and primarily geometric. This was an art that took its meaning solely from the viewer's perceptual experience of pure shape and color, with no reference to anything outside itself.

Takht-i-Sulayman Variation I is one of over a hundred paintings that make up the Protractor series (1967-1970). Architectural in scale and sculptural in their physical presence, with canvases attached to thick, oversized stretchers, the paintings form a set of complex variations on the protractor-drawn shape. In the Protractor series, this shape as a module is multiplied and joined in varying ways to establish thirty-one titled canvas formats, each of which Stella presents in three versions: interlaces, rainbows, and fans, referred to in the titles with Roman numerals I, II, and III, respectively.

The painting in the Shuey Collection is a special variation on the format named *Takht-i-Sulayman*. The original configuration centers two joined protractor-drawn shapes to form a circle that wedges itself into two horizontal protractor shapes that establish a base for the painting, all of which is flanked by vertical protractor shapes. This format creates a "shaped canvas," one of Stella's seminal innovations. The Shuey "variation," realized in the interlace version, takes this format and fills it out at the top with two inverted protractors that square the painting to the traditional rectangle. Stella carefully adjusted the saturation and value of his colors, deliberately juxtaposing them to strike a tense balance between spatial liveliness and assertive flatness. Unable to do this with manufacturer's pigments, which he had used in earlier work, he mixed colors himself, combining acrylic and fluorescent pigments. His orchestration of color bands is sumptuous: teal blue runs alongside a light peach; lavender is braced by slate gray and forest green; a lime green tucks itself between canary yellow and cranberry. The composition, in one reading, is stable and clear-cut, the shapes adamantly flat. But any sense of a design held in suspension is sabotaged by plays of color that send forms into endless fluctuation.

Stella's titles, always richly associative, provide a complication for formalist interpretations of the work. Most of the titles of the Protractor paintings are names of ancient circular cities in Asia Minor, four of which name Islamic cities. Takht-i-Sulayman was an Islamic capital in northwestern Persia. Founded in the 13th century, its name means "Throne of Solomon." Stella adds in evocative language another sensuous dimension to the visual specifics of his painting in plausible associations with city plans, monumental architecture, ancient spiritual capitals, and the interlacing geometric patterns of Islamic art whose ambiguities alluded to the unfathomable nature of Allah. Into the perceptual blend of beautiful color, shimmering light and mind-teasing form, Stella insinuated history and the exotic.

FRANK STELLA
(Born 1936, Malden, Massachusetts)
Warka II from the Polish Village Series,
1974
Wood, felt and canvas collage on board
93 x 112 inches (236.2 x 284.5 cm)
Signed on stretcher: "Warka #2
F. Stella 1974"

Acquired by Dr. John and Rose M. Shuey
through Sotheby Parke Bernet, New
York, New York, 1977

ADDITIONAL PROVENANCE
Knoedler Contemporary Art, New York,
New York

EXHIBITION HISTORY
Loan, San Francisco Museum of
Modern Art, San Francisco, California,
1975

By the time Frank Stella completed *Warka II*, he had elaborated upon his use of serialization and the "shaped canvas." He also had radicalized the flat surfaces of paintings with collage elements and literal depth. He was beginning to experiment with relief formats, which would lead to the emergence of his metal-relief paintings of the mid-1970s. The originality of his relief paintings lay in their materials, their three-dimensional projecting surfaces, and their form of manufacture: they are put together with a kit of discrete parts, resembling the working methods of assemblage more than traditional painting.

Warka II is one of over 130 paintings that compose the Polish Village series. Produced between 1970 and 1974, they were derived from forty designs, most of which Stella realized in three versions. In the first version, he collaged the sharply angular, interpenetrating forms of the series with painted canvas, felt, and paper over canvas. In the second version, represented by *Warka II*, planes of colored shapes either projected or receded but remained parallel to the wooden support to which they were attached. Here, Stella collaged a variety of materials onto a wooden support, including painted poster board, corrugated cardboard, canvas, Masonite, and felt. In the third version, the collaged planes were obliquely tilted and imagery was transformed into sculptural relief.

The effect of different and richly textured surfaces, flat or in relief, is to help separate the parts of these complex arrangements. Their colliding shapes confuse any sense of distinct form, not only in relation to where a form begins and ends, but also in relation to what projects and what does not. As in the Protractor paintings, Stella sets order and disorder against each other. Paralleling in spirit the vocabulary and energies of form associated with Russian Suprematism and Constructivism, *Warka II* holds its dynamic forms in suspension, a logical visual paradox of movement and stasis. These tensions of form, like those of *Takht-i-Sulayman Variation I*, are what hold our attention. *Warka II* also has associations that transcend the perceptual. The titles of the Polish Village paintings name Polish synagogues that were built between the seventeenth and nineteenth centuries, and destroyed by Hitler in the twentieth. The synagogues were wooden buildings that were unusual in their materials and carpentry, qualities that might be associated with Stella's painted and collaged wood "constructions." But Stella asserted that it was more a matter of associations than direct inspiration and that the series was more about "the obliteration of an entire culture" than the destroyed synagogues themselves.

What complicates these associations and further enriches meaning is that Stella chose to expand upon a style linked to the Russian and Soviet avant-garde and its ideologies. Constructivism was one of the art movements reviled by the Nazi government as "degenerate art," which was declared to be a conspiracy of Jewish and Bolshevik discontents. *Warka II* memorializes through title and abstract forms the tragic destruction of a people and its religious structures. Those very elegiac forms, however, also generate another set of associations that evokes modernism and, by extension, the triumphant spirit of the creative imagination.

FRANK STELLA
(Born 1936, Malden, Massachusetts)
Fanattia from Imaginary Places, 1995
Edition 10 of 24
Color etching, engraving, relief,
lithograph, stamping and mezzotint on
white TGL handmade paper
54 1/2 x 41 inches (138.4 x 104.1 cm)

Acquired by Dr. John and Rose M. Shuey
through M. Knoedler & Company, Inc.,
New York, New York, 1995

EXHIBITION HISTORY
*Frank Stella: Imaginary Places: New
Paintings and Prints*, M. Knoedler and
Company, Inc., New York, New York,
November 8, 1995–January 6, 1996

CITATIONS
Frank Stella: Imaginary Places (Mount
Kisco, New York: Tyler Graphics LTD,
1995), pp. 26, 27 (illus.).

Fanattia is one of twenty-five prints connected to a project entitled Imaginary Places. Making prints on a continuous basis since 1967, and accruing over 300 editions to date (notably with two of America's most important publishing workshops—Gemini G.E.L. and Tyler Graphics Ltd.), Stella has regarded his prints as intimately related to the paintings and of equal stature. The prints have always been responses to the paintings, taking the form of variations, or ambitious rephrasings of imagery that result from differences between paint and print media and Stella's original handling of them.

Stella has always extended the traditions of printmaking. His prints, particularly those made in collaboration with master printmaker Kenneth Tyler, have pushed the technical limits of prints, perhaps more than any other twentieth-century artist, with the exception of Picasso. *Fanattia* combines, in highly experimental ways, etching, engraving, relief printing, lithography, and mezzotint. The printing elements Stella created, both in wood and metal, were embedded into a base woodblock, effectively creating a metal assemblage. When inked, these plates were printed on hand-colored paper hot-stamped with silver foil. The total effect is of dense and dizzying colors and forms, interwoven as intricately as the color bands in *Takht-i-Sulayman Variation I*. Stella asserts the three primary colors of yellow, blue, and red in larger forms that cluster around an open embroidered pattern, whose loops shift through the secondaries of orange, purple, and green.

Printing from such blocks embedded with metal was not new to Stella's work. The artist derived them from fragments left over from the metal-relief paintings, thereby recycling and transposing refigured imagery from the paintings into the prints. In *Fanattia*, the imagery is both abstract and referential to varying degrees, including suggestions of computerized grids that warp and bend like Moebius strips, and smoke-ring imagery produced by computer graphics. Although flat, these swarming shapes, as they billow and twist, give *Fanattia* the illusion of complex three-dimensional spaces.

There is also a diagrammatic character to the assembled forms, derived from grid and circuit-like patterns that cover the hand-colored paper and the superimposed blue rectangle that serves as a brace for the swirling shapes. The title of the print furthers these associations. Taken from *The Dictionary of Imaginary Places*, compiled by Alberto Manguel and Gianni Guadalupi, it lists fictional locales drawn from literature. Fanattia is one of several imaginary islands that make up the Riallaro Archipelago, which is described in Godfrey Sweven's book *Riallaro, the Archipelago of Exiles*, published in 1901. The Archipelago's name means "ring of mist." *Fanattia*, then, evokes an abstractly topographical fantastical map, with the blue rectangle now sea-like as it surrounds the primary centered shapes of the island itself. Other titles in the print series Imaginary Places include *Despairia*, *Libertinia*, and *Swoonarie*. The islands and their inhabitants are undoubtedly identified with emotional states, just as *Fanattia* suggests "fanatical" forms.

—RICHARD H. AXSOM

VICTOR VASARELY
(Born 1908, Pécs, Hungary;
died 1997, Paris, France)
Toll from the Permutations Series,
1965
Tempera on board
31 1/2 x 31 1/2 inches (80 x 80 cm)
Signed lower center: "Vasarely"

Acquired by Dr. John and Rose M. Shuey
through Sidney Janis Gallery,
New York, New York, 1966

VICTOR VASARELY

Victor Vasarely's *Toll* plays with our perception in tantalizing and challenging ways. Our eyes seem pulled backward and forward in space, yet are kept in constant motion across the flat surface. Called one of the founders of Op Art, Vasarely explored patterns in his work that test ways in which eye and brain act to perceive the visible world. His studies culminated with his invention in 1959 of what he called "plastic unity." This artistic system was based on an alphabet of abstract shapes, which Vasarely believed expressed the structure of nature through their "affinities with the stars, atoms, cells, molecules . . . grains of sand, pebbles, foliage and flowers."

Born Gyozo Vasarhely in Pécs, Hungary, the artist took academic art training at Budapest's Podolini-Volkmann Academy, then studied graphic design with Alexander Bortnyik at Mühely, the so-called Budapest Bauhaus. There Vasarely learned graphic techniques based on Constructivist principles and Ostwald's color principles. He changed his name to Victor Vasarely after moving to Paris in 1930, and supported himself as a graphic artist until 1944, when he turned full time to painting.

Vasarely's early works were figurative, often including patterns and textures that pointed to his later art. In the 1950s, he developed his abstract vocabulary to represent "worlds which have hitherto eluded investigation by the senses; the worlds of biochemistry, or waves, of magnetic fields, of relativity." Each work was a starting-point, rather than an end in itself. Each could become a painting, a silkscreen print, a multiple, or a mural-scale part of a newly energized urban environment. Vasarely saw the artist as a "*plasticien*" who created art accessible to all, "for the physical and psychic well-being of humanity."

Vasarely's plastic unity works were created with repeatable shape elements (squares, circles, ovals, rhomboids, and/or triangles) set within the units of a checkerboard grid that filled each composition. The artist methodically charted on graph paper each design variant, using color schemes based on carefully constructed lists of the values for each color he used. Each composition and each color "score" was recorded meticulously in an *imagothèque* (picture library) notebook, with separate dates noted for the invention of each idea and its execution as a finished work.

Toll is part of Vasarely's Permutations series, in which the artist explored the optical effects of using a few shapes with gradients of two or three colors. In *Toll*, yellow circles occupy gray units in five outer nested rows, surrounding yellow squares in gray units of five inner nested rows. This pattern is countered by the division of the entire field into four quadrants, in each of which the yellow and the gray are taken through the color scale from light to dark (recalling the Ostwald color exercises that Vasarely did under Bortnyik in Budapest). In the upper right and lower left quadrants of *Toll*, the color scale moves from light at the outside to dark at the center. In the upper left and lower right quadrants, this is reversed so that the color scale moves from dark at the outer edge to light at the center. The result both optically warps the painting's flat surface and creates an amazing luminosity emanating from within the work. At one moment the outer-lighted quadrants seem to be floating above a dark-rimmed grid that covers the whole format. The next minute, the four quadrants lie on the same dynamic plane, with their sharp center "points" jousting against one another.

Toll is a mesmerizing image. It forces us to pay attention to how we see and find delight in the process of unraveling the tricks our eyes can play.

—DIANE KIRKPATRICK

ANDY WARHOL
(Born 1928, Pittsburgh, Pennsylvania;
died 1987, New York, New York)
Edson-Pelé from 10 Portraits of
Athletes, 1977
Acrylic and silkscreen on canvas
40 x 40 inches (101.6 x 101.6 cm)
Signed verso: "Edson-Pelé Andy
Warhol"

Acquired by Dr. John and Rose M. Shuey
through Sotheby's, New York, New York,
1981

ANDY WARHOL

Andy Warhol is known for announcing the fact that everyone should be famous for fifteen minutes. Indeed, fame was what drove Warhol. He cultivated it by his spectacularly cool persona, surrounded himself with famous people, and depicted fame in picture after picture of Hollywood celebrities, political figures, chic fashion personalities, rock musicians, well-known socialites, and star athletes, such as Portugese soccer star Pelé featured in *Edson-Pelé*. Andy Warhol was possibly the most important twentieth-century artist ushering in the era of postmodern art with its detached and ironic play of appropriated signs. He predicted the mass media's effect on society in pictures drawn from the exploding media culture around him. Displaying car crashes or electric chairs in repetitive serial fashion, Warhol demonstrated the anaesthesizing effect of seeing a tragic image over and over again. Similarly, the endless Coke bottles and Campbell's soup cans underscored the celebrated sameness and banality of the consumer culture in rapid growth. Warhol identified fame as an end product of media entertainment. From Marilyn Monroe to the FBI's Most Wanted list, all fame was equal, Warhol declared. When Valerie Solanis shot Warhol on June 3, 1968, she claimed she did it because he had too much control over her life. Warhol died almost twenty years later, but the control Solanis objected to was exactly what interested Warhol in his life study of mass culture.

Andy Warhol was born Andrew Warhola to Czech immigrants in Pennsylvania. He grew up in a Catholic household in Forest City but quickly tuned in to American popular culture. He recalled, for example, drawing at an early age by copying Maybelline ads of Hedy Lamarr. In 1949, Warhol graduated from Carnegie Tech with a graphic design degree and moved to New York City where he became a highly successful commercial artist working for such companies as I Miller shoes, Glamour, Tiffany's, and Doubleday Books. He was always aware, however, of the avant-garde art scene, in particular the work of Robert Rauschenberg and Jasper Johns, and in 1960, decided to become a serious artist. Warhol took on the classic subjects of Pop: comic book characters, consumer products, newspaper advertisements, etc. He began with a painterly kind of rendering following, in part, the model of New York's abstract expressionist movement, but quickly turned to silkscreening which gave him a more detached, mechanical, anti-expressionistic effect. Warhol went on to create the well-known Disaster Series, had a foray into film-making, did cow wallpaper as art, and created one of the hippest scenes in New York at his studio called The Factory. He became incredibly famous and in turn devoted his artistic attention to portraits of famous people.

The *Edson-Pelé* work is from a series of star athletes including Dorothy Hamill and Muhammad Ali from the late seventies. The style, however, is one he began in the early seventies when he introduced a looser, more brushy kind of painting in addition to the silkscreened image. Warhol would begin with snapshots of the famous personality under study, then convert the best one into a high-contrast photo silkscreen. He would then print onto a canvas already prepared with the brushy surface and add more paint if deemed necessary. The style is wonderfully effective in the Pelé portrait where the vibrantly colored passages of paint reverberate around Pelé's head as if released on contact with the soccer ball. It is a flattering portrait paying homage to one of the most talented athletes of the day and to the brand "Spalding" that features large in the composition—Andy Warhol never hesitated to fix on the reality of our post-industrial, consumer age.

—LISA WAINWRIGHT

TOM WESSELMANN
(Born 1931, Cincinnati, Ohio)
Smoker #18, 1975
Oil on canvas
89 3/4 x 91 3/4 inches (228 x 233 cm)

Acquired by Dr. John and Rose M. Shuey
through Sidney Janis Gallery, New York,
New York, 1977

EXHIBITION HISTORY
*Exhibition of New Paintings by
Wesselmann*, Sidney Janis Gallery,
New York, New York,
April 21–May 22, 1976

CITATIONS
*Exhibition of New Paintings by
Wesselmann*, Exh. cat. (New York:
Sidney Janis Gallery, 1976), cat. no. 7
(illus.).

TOM WESSELMANN

Tom Wesselmann explored some of the brashest and most charged imagery of all the group of Pop artists who came of age in the early 1960s. His monumental recumbent nudes, drawn from the ample stock of advertising's alluring females, will forever hold a place in our historical consciousness as strident icons of the era's so-called sexual revolution. Part pin-up, part odalisque, Wesselmann's women were all breast, lip and pudenda; they unapologetically offered up a faceless female eroticism that matched the anonymity of mass advertising's ubiquitous exploitation of women. *Smoker #18* relies on the common image of the sexy female smoker with cigarette perched on parted lips, but its attenuated full mouth clearly evolved from the fetishized body parts of the Great American Nude series. Wesselmann's picture goes beyond mere re-presentation of a Madison Avenue type, however, for *Smoker #18*'s strange rendering evokes a broader visionary fancy.

Wesselmann was born in a suburb of Cincinnati. He had little exposure to art and taught himself drawing while in the army creating gag cartoons. He quickly acknowledged his passion and pursued formal study in Cincinnati and then at Cooper Union in New York City. Although gestural abstraction was the rage at the time, in 1959 Wesselmann made the conscious decision to abandon this expressionistic style in favor of reorienting found images and materials. He began with small collages of figures and landscapes, and gradually added more objects while increasing the size of the work. Televisions, radios, bathroom fixtures, commercial signs and labels, cabinets, and clocks, all eventually made their way into his paintings. Elaborate still lifes dominated his oeuvre with erotic nudes posed amidst the newly efficient packaged foods, cars, and appliances of the American Dream.

Wesselmann disliked the Pop label, preferring to think of himself as exploring ideas larger than those his commercial motifs ostensibly implied. *Smoker #18* exemplifies this well in that the strength of its form overwhelms the simple recognition of an everyday advertisement elevated to the status of art. The work is painted in the artificially perfect colors and modulated crispness of a commercial technique, albeit large scale and dramatically shaped. The shaped canvas reinforces the evocative curve of the lips that nestle a fluid stream of smoke, which in turn meanders up the right side of the composition. The mouth, surrealistically exaggerated, falls agape revealing a perilously dark interior. The fingers of the hand are plump with a fleshy ripeness matched by the glossy wetness of the lips that meet it in close juxtaposition. Taste, touch, red, wet, hot, shiny, deep, dark, rigid, shapely, flesh, and smoke describe Wesselmann's suggestive tone in *Smoker #18*. Since his first one-person show at Tanager Gallery in New York in 1961, Wesselmann has gone on to produce more work around the figure, landscapes and still lifes in ever inventive compositions and materials and always with a predilection for the sensual.

—LISA WAINWRIGHT

ESSAY SOURCES

JOSEF ALBERS
Josef Albers: A Retrospective. New York: Solomon R. Guggenheim Museum, 1988.

Spies, Werner. *Albers.* New York: Harry N. Abrams, Inc., 1970.

RICHARD ANUSZKIEWICZ
Lunde, Karl. *Richard Anuszkiewicz.* New York: Harry N. Abrams, Inc., 1977.

Seitz, William. *The Responsive Eye.* New York: The Museum of Modern Art, 1965.

JEAN ARP
Soby, James Thrall. *Arp.* New York: The Museum of Modern Art, 1958.

Trier, Eduard. *Jean Arp Sculpture: His Last Ten Years.* New York: Harry N. Abrams, Inc., 1968.

JO BAER
Baer, Jo. "I am no longer an abstract artist." *Art in America* 71 (October 1983): 136-37.

Baer, Jo, Marja Bloem, Marianne Brouwer and Rudi Fuchs. *Jo Baer: Painting 1960-1998.* Amsterdam: Stedelijk Museum, 1999.

Haskell, Barbara. *Jo Baer.* New York: The Whitney Museum of American Art, 1975.

ANTHONY CARO
Fenton, Terry. *Anthony Caro.* New York: Rizzoli, 1986.

Moorhouse, Paul. *Anthony Caro: Sculpture Towards Architecture.* London: Tate Gallery, 1991.

Whelan, Richard. *Anthony Caro.* New York: E.P. Dutton, 1975.

RICHARD DIEBENKORN
Flam, Jack D. *Richard Diebenkorn, "Ocean Park."* New York: Rizzoli, 1992.

Livingston, Jane, with essays by John Elderfield, Ruth Fine, and Jane Livingston. *The Art of Richard Diebenkorn.* Berkeley: University of California Press, 1997.

Nordland, Gerald. *Richard Diebenkorn.* New York: Rizzoli, 2001.

JIM DINE
Beal, Graham W. J., with contributions by Robert Creeley, Jim Dine, and Martin Friedman. *Jim Dine: Five Themes.* Minneapolis: Walker Art Center; New York: Abbeville Press, 1984.

Cunningham, Marco, with commentary by Jim Dine. *Jim Dine: The Alchemy of Images.* New York: Monacelli Press, 1998.

Feinberg, Jean E. *Jim Dine.* New York: Abbeville Press, 1995.

JEAN DUBUFFET
Jean Dubuffet: A Retrospective. Greenwich, Connecticut: New York Graphic Society, 1973.

Jean Dubuffet: Les Dernières Années. Paris: Galerie Nationale du Jeu de Paume, 1991.

Jean Dubuffet: Towards an Alternative Reality. New York: Abbeville, 1987.

SAM FRANCIS
Lembark, Connie, with an introduction by Ruth E. Fine. *The Prints of Sam Francis: A Catalogue Raisonné 1960-1990.* New York: Hudson Hills Press, 1992.

Sam Francis: Elements and Archetypes. Essays by Donald Kuspit, Robert Shapazian and Michael Zakian. Madrid: Fundación Caja de Madrid, in association with the University of Washington Press, 1997.

Selz, Peter, with an essay by Susan Einstein and Jan Butterfield. *Sam Francis.* New York: Harry N. Abrams, Inc., 1982.

BARBARA HEPWORTH
Bowness, Alan. *Barbara Hepworth: A Pictorial Autobiography.* London: Tate Gallery Publications, 1985.

Festing, Sally. *Barbara Hepworth: A Life of Forms.* London: Viking, 1995.

Gale, Matthew, and Chris Stephens. *Barbara Hepworth: Works in the Tate Gallery Collection and the Barbara Hepworth Museum, St. Ives.* London: Tate Gallery Publishing, 1999.

JOSEPH HIRSCH
Joseph Hirsch. Athens, Georgia: Georgia Museum of Art, University of Georgia, 1970.

"Joseph Hirsch (1910-1981)." *Naval Historical Center.* Available [Online]: http://www.history.navy.mil/ac/artist/h/Hirsch/hirsch1.htm.

"Oral History Interview with Joseph Hirsch—Tape 1 in His Studio at 246 West 80th Street, New York City, November 13, 1970." *Smithsonian Archives of American Art.* Available [Online]: http://www.aaa.si.edu/orlhist/hirsch70.htm.

PAUL JENKINS
Cassou, Jean. *Jenkins.* New York: Harry N. Abrams, Inc., 1964.

Jenkins, Paul. *Paul Jenkins.* New York: Harry N. Abrams, Inc., 1973.

Jenkins, Paul. *Paul Jenkins, Anatomy of a Cloud.* New York: Harry N. Abrams, Inc., 1983.

ALFRED JENSEN
Cathcart, Linda L., and Marcia Tucker. *Alfred Jensen: Paintings and Diagrams from the Years 1957-1977.* Buffalo, New York: Albright-Knox Art Gallery, 1978.

Glueck, Grace. "Overpowering Colors And Dizzying Theories." *The New York Times,* 28 September 2001, E32.

Jensen, Mrs. Regina Bogat, the artist's wife. Telephone conversation with author, 29 September 2001.

Judd, Donald. "New York Exhibitions: In the Galleries—Al Jensen." *Arts Magazine* 37(April 1963): 52.

DONALD JUDD
Bois, Yve-Alain. *Donald Judd, New Sculpture.* New York: Pace Gallery, 1991.

Del Balso, D., R. Smith and B. Smith. *Donald Judd: Catalogue Raisonné of Paintings, Objects and Wood Blocks 1960-1974.* Ottawa: The National Gallery, 1975.

Raskin, David. "Specific Opposition: Judd's Art and Politics." *Art History* 24:5 (November 2001): 682-706.

WILLIAM KING
Senie, Harriet. "King's Kingdom." *Art News* 85 (Summer 1986): 104-110.

WILLEM DE KOONING
Cummings, Paul. *Willem de Kooning, Drawings, Paintings, Sculpture: New York, Berlin, Paris.* New York: W.W. Norton, 1983.

Willem de Kooning: Drawings and Sculpture. Essay by Peter Schjeldahl. New York: Matthew Marks Gallery and Mitchell-Innes & Nash, 1998.

Willem de Kooning Sculpture. Texts by Andrew Forge, David Sylvester, and William Tucker. New York: Matthew Marks Gallery, 1996.

NICHOLAS KRUSHENICK
"Forward" and "Meet Nicholas Krushenick." In *Nicholas Krushenick.* Hanover: Kestner-Gesellschaft, 1972.

Halley, Peter. "Pop Secret: Nicholas Krushenick." *Artforum International* 37:9 (May 1999): 68.

Perrault, John. "Krushenick's Blazing Blazons." *Art News* 66:1 (March 1967): 34, 72-3.

Robbins, Connie. "The Artist Speaks: Nicholas Krushenick." *Art in America* 57 (May-June 1969): 60-65.

ROY LICHTENSTEIN
Alloway, Lawrence. *Roy Lichtenstein.* New York: Abbeville Press, 1983.

Waldman, Diane. *Roy Lichtenstein.* New York: Guggenheim Museum, 1993.

AGNES MARTIN
Eisler, Benita. "Agnes Martin." *The New Yorker,* 25 January 1993, 70-83.

Haskell, Barbara. *Agnes Martin.* New York: Whitney Museum of American Art, 1993.

Martin, Agnes. *Writings*. Edited by Dieter Schwarz. Germany and Switzerland: Edition Cantz and Kunstmuseum Winterthur, 1992.

JOAN MITCHELL
Kertess, Klaus. *Joan Mitchell*. New York: Harry N. Abrams, Inc., 1997.

Sandler, Irving. *The New York School: The Painters and Sculptors of the Fifties*. New York: Harper and Row, 1978.

ROBERT MOTHERWELL
Arnason, H.H. *Robert Motherwell*. New York: Harry N. Abrams, Inc., 1977.

Caws, Mary Ann. *Robert Motherwell: What Art Holds*. New York: Columbia University Press, 1996.

Rosand, David, ed. *Robert Motherwell on Paper: Drawings, Prints, Collages*. New York: Harry N. Abrams, Inc., 1997.

CATHERINE MURPHY
Henry, Gerrit. "The Figurative Field." *Art in America* 82 (January 1994): 82-88.

Loke, Margaret. "Catherine Murphy: It Chose Her." *Art News* 95:2 (February 1996): 96.

Nochlin, Linda. "Catherine Murphy: The Enchantment of the Visual." *Catherine Murphy: New Paintings and Drawings 1980-1985*. New York: Xavier Fourcade, Inc., 1985.

ELIZABETH MURRAY
Smith, Roberta, and Clifford Ackley, with an interview with Elizabeth Murray by Sue Graze and Kathy Halbreich. *Elizabeth Murray: Paintings and Drawings*. Dallas, Texas, and Cambridge, Massachusetts: Dallas Museum of Fine Arts and Albert and Vera List Visual Arts Center, Massachusetts Institute of Technology, 1987.

Rogers-Lafferty, Susan. *Recent Work by Elizabeth Murray*. Columbus, Ohio: Wexner Center for the Arts, The Ohio State University, 1991.

LOUISE NEVELSON
Friedman, Martin. *Nevelson: Wood Sculptures*. New York: E.P. Dutton, 1973.

Glimcher, Arnold B. *Louise Nevelson*. New York: Praeger, 1972.

Nevelson, Louise. *Dawns + Dusks*. New York: Charles Scribner, 1976.

KENNETH NOLAND
Fried, Michael. *Three American Painters: Kenneth Noland, Jules Olitski, Frank Stella*. Cambridge, Massachusetts: Fogg Art Museum, 1965.

Kenneth Noland: An Important Exhibition of Paintings from 1958 through 1989. Essay by Terry Fenton and reprinted writings by Ken Carpenter. New York: Salander-O'Reilly Galleries, 1989.

Waldman, Diane. *Kenneth Noland: A Retrospective*. New York: Solomon R. Guggenheim Foundation, 1977.

CLAES OLDENBURG
Axsom, Richard H., and David Platzker. *Printed Stuff: Prints, Posters, and Ephemera by Claes Oldenburg*. New York: Hudson Hills Press in association with the Madison Art Center, Wisconsin, 1997.

Claes Oldenburg: An Anthology. Texts by German Celant, Dieter Koepplin, Claes Oldenburg, Marla Prather and Mark Rosenthal. New York: Solomon R. Guggenheim Museum, 1995.

Claes Oldenburg/Coosje van Bruggen/Large-Scale Projects. New York: Monacelli Press, 1994.

JULES OLITSKI
Geldzahler, Henry, Tim Hilton and Dominique Fourcade. *Jules Olitski*. New York: Salander O'Reilly Galleries, 1990.

Moffet, Kenworth. *Jules Olitski*. New York: Harry N. Abrams, Inc., 1981.

PHILIP PEARLSTEIN
Perreault, John. *Philip Pearlstein: Drawings and Watercolors*. New York: Harry N. Abrams, Inc., 1988.

Philip Pearlstein: A Retrospective. New York: Alpine Fine Arts Collection, 1983.

Viola, Jerome. *The Painting and Teaching of Philip Pearlstein*. New York: Watson-Guptill, 1982.

LARRY POONS
Larry Poons, Paintings 1963-1990. Essay by Daniel Robbins and an interview by John Zinsser. New York: Salander-O'Reilly Galleries, 1990.

Moffett, Kenworth. *Larry Poons Paintings, 1971-1981*. Boston: Boston Museum of Fine Arts, 1981.

ROBERT RAUSCHENBERG
Hopps, Walter and Susan Davidson. *Robert Rauschenberg: A Retrospective*. New York: Harry N. Abrams, Inc., 1997.

Wainwright, Lisa. "Robert Rauschenberg's Fabrics: Constructing Domestic Space." In *Not at Home: The Suppression of Domesticity in Modern Art and Architecture*, edited by Christopher Reed. London: Thames and Hudson, 1996.

BRIDGET RILEY
Kudielka, Robert, ed. *The Eye's Mind: Bridget Riley Collected Writings 1965-1999*. London: Thames & Hudson in association with the Serpentine Gallery and De Montfort University, 1999.

Melville, Robert. "An Art Without Accidents." *New Statesman*, 23 July 1971.

Thompson, David. *Bridget Riley*. New York: Sidney Janis Gallery, 1975.

DOROTHEA ROCKBURNE
Dorothea Rockburne. Waltham, Massachusetts: Rose Art Museum, 1989.

Dorothea Rockburne—Drawing: Structure and Curve. New York: John Weber, 1978.

ZOLTAN SEPESHY
Schmeckebier, Laurence. *Zoltan Sepeshy: Forty Years of His Work*. Syracuse, New York: The School of Art, Syracuse University; Bloomfield Hills, Michigan: Cranbrook Academy of Art Museum, 1966.

Sepeshy, Zoltan. "I Don't Like Labels." *Magazine of Art* 38 (May 1945): 186-189.

SAUL STEINBERG
Barthes, Roland. *All Except You: Saul Steinberg*. France: Galerie Maeght, 1983.

Boxer, Sarah. "Saul Steinberg, Epic Doodler, Dies at 84." *New York Times*, 13 May 1999, 1.

Rosenberg, Harold. *Saul Steinberg*. New York: Alfred A. Knopf and Whitney Museum of American Art, 1978.

Stevens, Mark. "Steinberg's Masks." *Newsweek*, 17 April 1978, 124-126.

FRANK STELLA
Axsom, Richard H., with the assistance of Phyllis Floyd and Matthew Rohn. *The Prints of Frank Stella: A Catalogue Raisonné, 1967-1982*. New York: Hudson Hills Press; Ann Arbor: University of Michigan Museum of Art, 1983.

Rubin, William S. *Frank Stella*. New York: The Museum of Modern Art, 1970.

Rubin, William S. *Frank Stella, 1970-1987*. New York: The Museum of Modern Art, 1987.

VICTOR VASARELY
Diehl, Gaston. *Vasarely*. Translated by Eileen B. Hennessy. New York: Crown Publishers, Inc., 1972.

Spies, Werner. *Vasarely*. Translated by Leonard Mins. New York: Harry N. Abrams, Inc.; Stuttgart: Verlag Gerd Hatje, 1969.

Spies, Werner. *Victor Vasarely*. Translated by Robert Erich Wolf. New York: Harry N. Abrams, Inc., 1971.

Vasarely, Victor. *Planetary Folklore*. Translated by Cedric Hentschel. Munich: Verlag F. Bruckmann KG, 1973.

Vasarely, Victor. *Plasticien*. Paris: Robert Laffont, 1979.

ANDY WARHOL
Andy Warhol: Portraits of the Seventies and Eighties. Essays by Henry Geldzahler and Robert Rosenblum. London: Anthony d'Offray Gallery, 1993.

Warhol, Andy. *The Philosophy of Andy Warhol: From A to B and Back Again*. London: Pan Books, 1979.

TOM WESSELMANN
Hunter, Sam. *Tom Wesselmann*. New York: Rizzoli, 1994.

Wesselmann, Tom. *Tom Wesselmann/Slim Stealingworth*. New York: Abbeville Press, 1980.

CRANBROOK EDUCATIONAL COMMUNITY